Francis Frith's
GREAT YARMOUTH

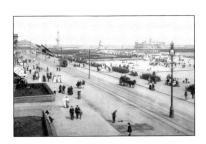

Francis Frith's
GREAT YARMOUTH

◆

Clive Tully

First published in the United Kingdom in 2000 by
Frith Book Company Ltd

Hardback Edition 2000
ISBN 1-85937-085-3

Paperback Edition 2001
ISBN 1-85937-426-3

British Library Cataloguing in Publication Data

Francis Frith's Great Yarmouth
Clive Tully

Frith Book Company Ltd
Frith's Barn, Teffont,
Salisbury, Wiltshire SP3 5QP
Tel: +44 (0) 1722 716 376
Email: info@frithbook.co.uk
www.frithbook.co.uk

Printed and bound in Great Britain

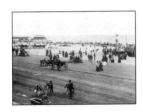

CONTENTS

FRANCIS FRITH: *Victorian Pioneer*

FRANCIS FRITH, Victorian founder of the world-famous photographic archive, was a complex and multitudinous man. A devout Quaker and a highly successful Victorian businessman, he was both philosophic by nature and pioneering in outlook.

By 1855 Francis Frith had already established a wholesale grocery business in Liverpool, and sold it for the astonishing sum of £200,000, which is the equivalent today of over £15,000,000. Now a multi-millionaire, he was able to indulge his passion for travel. As a child he had pored over travel books written by early explorers, and his fancy and imagination had been stirred by family holidays to the sublime mountain regions of Wales and Scotland. 'What a land of spirit-stirring and enriching scenes and places!' he had written. He was to return to these scenes of grandeur in later years to 'recapture the thousands of vivid and tender memories', but with a different purpose. Now in his thirties, and captivated by the new science of photography, Frith set out on a series of pioneering journeys to the Nile regions that occupied him from 1856 until 1860.

INTRIGUE AND ADVENTURE

He took with him on his travels a specially-designed wicker carriage that acted as both dark-room and sleeping chamber. These far-flung journeys were packed with intrigue and adventure. In his life story, written when he was sixty-three, Frith tells of being held captive by bandits, and of fighting 'an awful midnight battle to the very point of surrender with a deadly pack of hungry, wild dogs'. Sporting flowing Arab costume, Frith arrived at Akaba by camel seventy years before Lawrence, where he encountered 'desert princes and rival sheikhs, blazing with jewel-hilted swords'.

During these extraordinary adventures he was assiduously exploring the desert regions bordering the Nile and patiently recording the antiquities and peoples with his camera. He was the first photographer to venture beyond the sixth cataract. Africa was still the mysterious 'Dark Continent', and Stanley and Livingstone's historic meeting was a decade into the future. The conditions for picture taking confound belief. He laboured for hours in his wicker dark-room in the sweltering heat of the desert, while the volatile chemicals fizzed dangerously in their trays. Often he was forced to work in remote tombs and caves

where conditions were cooler. Back in London he exhibited his photographs and was 'rapturously cheered' by members of the Royal Society. His reputation as a photographer was made overnight. An eminent modern historian has likened their impact on the population of the time to that on our own generation of the first photographs taken on the surface of the moon.

VENTURE OF A LIFE-TIME

Characteristically, Frith quickly spotted the opportunity to create a new business as a specialist publisher of photographs. He lived in an era of immense and sometimes violent change. For the poor in the early part of Victoria's reign work was a drudge and the hours long, and people had precious little free time to enjoy themselves.

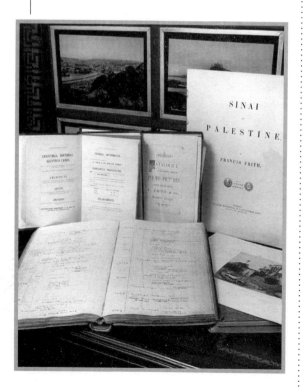

Most had no transport other than a cart or gig at their disposal, and had not travelled far beyond the boundaries of their own town or village. However, by the 1870s, the railways had threaded their way across the country, and Bank Holidays and half-day Saturdays had been made obligatory by Act of Parliament. All of a sudden the ordinary working man and his family were able to enjoy days out and see a little more of the world.

With characteristic business acumen, Francis Frith foresaw that these new tourists would enjoy having souvenirs to commemorate their days out. In 1860 he married Mary Ann Rosling and set out with the intention of photographing every city, town and village in Britain. For the next thirty years he travelled the country by train and by pony and trap, producing fine photographs of seaside resorts and beauty spots that were keenly bought by millions of Victorians. These prints were painstakingly pasted into family albums and pored over during the dark nights of winter, rekindling precious memories of summer excursions.

THE RISE OF FRITH & CO

Frith's studio was soon supplying retail shops all over the country. To meet the demand he gathered about him a small team of photographers, and published the work of independent artist-photographers of the calibre of Roger Fenton and Francis Bedford. In order to gain some understanding of the scale of Frith's business one only has to look at the catalogue issued by Frith & Co in 1886: it runs to some 670

pages, listing not only many thousands of views of the British Isles but also many photographs of most European countries, and China, Japan, the USA and Canada – note the sample page shown above from the hand-written *Frith & Co* ledgers detailing pictures taken. By 1890 Frith had created the greatest specialist photographic publishing company in the world, with over 2,000 outlets – more than the combined number that Boots and WH Smith have today! The picture on the right shows the *Frith & Co* display board at Ingleton in the Yorkshire Dales. Beautifully constructed with mahogany frame and gilt inserts, it could display up to a dozen local scenes.

POSTCARD BONANZA

◆◆

The ever-popular holiday postcard we know today took many years to develop. In 1870 the Post Office issued the first plain cards, with a pre-printed stamp on one face. In 1894 they allowed other publishers' cards to be sent through the mail with an attached adhesive halfpenny stamp. Demand grew rapidly, and in 1895 a new size of postcard was permitted called the

court card, but there was little room for illustration. In 1899, a year after Frith's death, a new card measuring 5.5 x 3.5 inches became the standard format, but it was not until 1902 that the divided back came into being, with address and message on one face and a full-size illustration on the other. *Frith & Co* were in the vanguard of postcard development, and Frith's sons Eustace and Cyril continued their father's monumental task, expanding the number of views offered to the public and recording more and more places in Britain, as the coasts and countryside were opened up to mass travel.

Francis Frith died in 1898 at his villa in Cannes, his great project still growing. The archive he created continued in business for another seventy years. By 1970 it contained over a third of a million pictures of 7,000 cities, towns and villages. The massive photographic record Frith has left to us stands as a living monument to a special and very remarkable man.

Frith's Archive: *A Unique Legacy*

FRANCIS FRITH'S legacy to us today is of immense significance and value, for the magnificent archive of evocative photographs he created provides a unique record of change in 7,000 cities, towns and villages throughout Britain over a century and more. Frith and his fellow studio photographers revisited locations many times down the years to update their views, compiling for us an enthralling and colourful pageant of British life and character.

We tend to think of Frith's sepia views of Britain as nostalgic, for most of us use them to conjure up memories of places in our own lives with which we have family associations. It often makes us forget that to Francis Frith they were records of daily life as it was actually being lived in the cities, towns and villages of his day. The Victorian age was one of great and often bewildering change for ordinary people, and though the pictures evoke an impression of slower times, life was as busy and hectic as it is today.

We are fortunate that Frith was a photographer of the people, dedicated to recording the minutiae of everyday life. For it is this sheer wealth of visual data, the painstaking chronicle of changes in dress, transport, street layouts, buildings, housing, engineering and landscape that captivates us so much today. His remarkable images offer us a powerful link with the past and with the lives of our ancestors.

TODAY'S TECHNOLOGY

Computers have now made it possible for Frith's many thousands of images to be accessed almost instantly. In the Frith archive today, each photograph is carefully 'digitised' then stored on a CD Rom. Frith archivists can locate a single photograph amongst thousands within seconds. Views can be catalogued and sorted under a variety of categories of place and content to the immediate benefit of researchers. Inexpensive reference prints can be created for them at the touch of a mouse button, and a wide range of books and other printed materials assembled and published for a wider, more general readership - in the next twelve months over a hundred Frith local history titles will be published! The

See Frith at www. frithbook.co.uk

10

day-to-day workings of the archive are very different from how they were in Francis Frith's time: imagine the herculean task of sorting through eleven tons of glass negatives as Frith had to do to locate a particular sequence of pictures! Yet the archive still prides itself on maintaining the same high standards of excellence laid down by Francis Frith, including the painstaking cataloguing and indexing of every view.

It is curious to reflect on how the internet now allows researchers in America and elsewhere greater instant access to the archive than Frith himself ever enjoyed. Many thousands of individual views can be called up on screen within seconds on one of the Frith internet sites, enabling people living continents away to revisit the streets of their ancestral home town, or view places in Britain where they have enjoyed holidays. Many overseas researchers welcome the chance to view special theme selections, such as transport, sports, costume and ancient monuments.

We are certain that Francis Frith would have heartily approved of these modern developments, for he himself was always working at the very limits of Victorian photographic technology.

THE VALUE OF THE ARCHIVE TODAY

Because of the benefits brought by the computer, Frith's images are increasingly studied by social historians, by researchers into genealogy and ancestory, by architects, town planners, and by teachers and schoolchildren involved in local history projects. In addition, the archive offers every one of us a unique opportunity to examine the places where we and our families have lived and worked down the years. Immensely successful in Frith's own era, the archive is now, a century and more on, entering a new phase of popularity.

THE PAST IN TUNE WITH THE FUTURE

Historians consider the Francis Frith Collection to be of prime national importance. It is the only archive of its kind remaining in private ownership and has been valued at a million pounds. However, this figure is now rapidly increasing as digital technology enables more and more people around the world to enjoy its benefits.

Francis Frith's archive is now housed in an historic timber barn in the beautiful village of Teffont in Wiltshire. Its founder would not recognize the archive office as it is today. In place of the many thousands of dusty boxes containing glass plate negatives and an all-pervading odour of photographic chemicals, there are now ranks of computer screens. He would be amazed to watch his images travelling round the world at unimaginable speeds through network and internet lines.

The archive's future is both bright and exciting. Francis Frith, with his unshakeable belief in making photographs available to the greatest number of people, would undoubtedly approve of what is being done today with his lifetime's work. His photographs, depicting our shared past, are now bringing pleasure and enlightenment to millions around the world a century and more after his death.

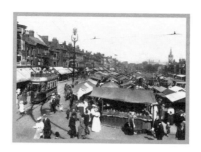

GREAT YARMOUTH – *An Introduction*

ALTHOUGH THE EARLIEST reference to Yarmouth is in the Domesday Book, its origins go a lot further back. It was back in Roman times, when the forts at Caister (north of Yarmouth) and Burgh Castle (to the south-west, now inland) stood on the estuary of a large river, that a sandbank began to build up. It was a wild and windy place, and the reason the first settlers came here - undoubtedly fishermen - was because the sea was absolutely alive with fish. As the settlement grew, what started as just a small gathering of fishermen grew into a thriving port.

The town's prosperity was founded on herring fishing. In medieval Europe, herring was an important foodstuff: it was nutritious, and it kept well if smoked. Small wonder it was supplied to everyone from peasants to nobility. From Yarmouth the fish was exported all over Europe, and by the middle of the 13th century the town was booming. The first forty-day-long Great Yarmouth Herring Fair was held in 1270; little were they to know that it would carry on annually for another five hundred years. The fishing industry reached its height in the 19th century, thanks to better-equipped boats and the arrival of the railways,

which ensured better distribution. In the 1860s fishermen from Scotland started to arrive. They brought with them a method for pickling the fish in brine, rather than the traditional method of smoking which produced the Yarmouth bloater. So popular was it that pickled herring overtook smoked herring in popularity by the turn of the century.

By now, Great Yarmouth was the leading herring port in the world. During the season, which lasted about ten weeks from the end of September, the town's population would be swelled by thousands - by fishermen, their wives and daughters who gutted and pickled the fish, and the coopers to make the barrels the fish were transported in. The sailing boats were superseded by steam drifters, once more revolutionising the industry. Catches soared, but then the First World War intervened. The steam drifters were requisitioned for mine-sweeping duties, and by the time they were back fishing, markets had dwindled. There was a brief resurgence after the Second World War, but by the mid 1950s it was clear that fish stocks were seriously depleted. By the time they were sold in the early sixties, Yarmouth's fleet of fishing boats had dwindled to six.

Up to the middle of the 14th century, all but the smallest of ships were unable to sail into the harbour, or haven; they had to unload at sea, anchored in Yarmouth Roads, the navigable stretch between the coast and sandbanks offshore. The longshore drift which produced the sandbank on which Yarmouth is built is a constant action, and as the flow out of the river mouth was not strong enough to scour it out, it continually choked up with sand and shingle. In 1347, a new outlet for the river was created closer to the town to provide an entrance to the harbour. It was a failure, and the next two hundred years saw successive attempts to create harbour entrances which would not silt up, each at different locations. The seventh attempt in 1560 saw a Dutch expert brought in at great expense to supervise the building of a new cut, this time stabilised by wooden piling. It worked, and it survives to this day as Yarmouth's harbour entrance.

But apart from the fishing, there was general trade too. The quay in Yarmouth was described by Daniel Defoe as 'the finest quay in England, if not Europe'. It would be hard to disagree, for its broad quays are up to a hundred and fifty yards wide in places, and are lined with magnificent merchants' houses.

Yarmouth gained the first of its twenty-five charters in 1208, granted by King John. Just over fifty years later, Henry III gave the town permission to build a town wall and moat, to protect the three sides which were not backing on to the river. Over a mile long, seven feet thick and with sixteen towers and ten gates, the wall was to turn Yarmouth into a something of a fortress, although lack of money and the ravages of the plague meant it was not completed until the reign of Edward III. There was a castle at the centre of the walled town as well, but it only survived until 1621, when it was ordered to be demolished. But defining the outer perimeter meant making sure everyone could fit in. Houses were crammed close together, and so the famous and unique Yarmouth 'Rows' were born. Passageways between the blocks of houses could be as narrow as thirty inches, and spe-

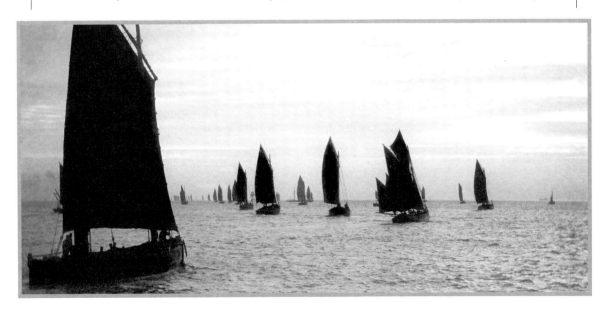

cial carts called trolls were developed to negotiate the wider alleyways; twelve feet long and three and a half feet across, their wheels were set beneath the body of the cart rather than on the outside. The Rows - a hundred and fifty-six of them - all had names, many taken from nearby inns; some names were picturesque, like Kitty Witches Row and

Bishop of Norwich and founder of Norwich Cathedral. Over the years, it expanded with the town, so that the initial cruciform shape was filled out to make a rectangular shape, eventually fulfilling a claim to be the largest parish church in England. De Losinga built a priory, too, but it did not survive the dissolution.

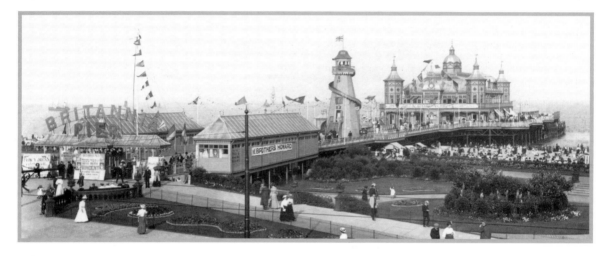

Snatchbody Row (named after the body-snatchers Vaughan and Murphy, who lived here in the 19th century). The Rows were also given numbers at the beginning of the 19th century to avoid confusion. Charles Dickens, who spent some time in Yarmouth, described the Rows as like a grid-iron.

By today's standards, the Rows were dark, dingy and overcrowded, with crude sanitation; but despite these bad conditions, there was very little sickness, attributed to the constant draught of air along the narrow passages. Indeed, Yarmouth records numerous cases of longevity, including Matthew Champion, who died in 1793 aged 111, and Luke Waller, who died in 1824 at the age of 105!

The church of St Nicholas was built in 1101 by Bishop Herbert de Losinga, the

Yarmouth MP Miles Corbet supported Parliament during the Civil War, and such was his allegiance and friendship with Cromwell that he was one of the signatories to Charles I's death warrant. When the Crown was restored, he fled to Holland, but was arrested in 1662 and brought back to stand trial. Condemned to death for high treason, he was hanged, drawn and quartered at Tyburn.

Although Yarmouth made its name on herring fishing, it was also a great centre of ship-building, which gave it a great deal of clout as a naval port. By the 14th century, Yarmouth had its own navy comprising twenty men-of-war, which was more fire-power than could be mustered even by London at the time. And in 1799, Admiral Duncan sailed from here to defeat the Dutch fleet off Camperdown, returning with several captured ships.

Great Yarmouth was visited by Norfolk's most famous son and England's greatest sailor, Horatio Nelson. He first came in 1800, when he arrived with his lover Lady Emma Hamilton (and her husband!) to receive a hero's welcome after the Battle of the Nile. After his death at Trafalgar, Great Yarmouth was chosen as the most fitting place for a Norfolk memorial to Nelson, sited on the coast. Designed by Norfolk-born architect William Wilkins - also responsible for the National Gallery in London and the famous Gothic screen in front of King's College, Cambridge - the 144 feet tall monument was erected in 1819, twenty-four years before the taller and better-known column which stands in London's Trafalgar Square. But unlike the London model, it is not topped with a statue of the man himself. Instead it is graced by Britannia, facing towards Burnham Thorpe, Nelson's birthplace on the North Norfolk coast.

Other famous names connected with Great Yarmouth include Charles Dickens, who stayed at the Royal Hotel on Marine Parade in 1848 while researching 'David Copperfield', and the author of 'Black Beauty', Anna Sewell, who was born in 1820 in a delightful timbered house near St Nicholas's church which survives to this day.

Great Yarmouth's popularity as a holiday resort goes back to the mid 18th century with the building of a bath house. Salt water at the time was taken both internally and externally as a cure-all, and fashionable society took to it with a vengeance. Early bathers did not bother with costumes, but as their numbers increased, the ladies demanded modesty: thus the bathing machine was invented, a changing-room on wheels dragged down to the water's edge by a horse, with steps down from which the bather could enter the sea, shielded from view by a canvas hood. By late Victorian times, the hoods were more or less dispensed with, and bathers instead wore the more familiar 'reach-me-down' costumes.

The resort began to develop seriously in the 1840s with the arrival of the railway, which brought large numbers of visitors from the industrial midlands and the north to enjoy the miles of beautiful sandy beaches. In Francis White & Co.'s 1854 edition of 'History, Gazetteer and Directory of Norfolk', the beach, inns, numerous lodging houses, bathing machines and public gardens all made Yarmouth a place where 'pleasure and exercise may at all times be enjoyed in an infinitude of shapes'.

By the end of the 1850s both Britannia and Wellington Piers had been built. When their respective pavilions were added later, there began a long rivalry between the two in their attempts to put on the best shows and attract the biggest stars. Today, the theatre on Britannia Pier is owned by popular comedian Jim Davidson. In 1908, the Gem became one of the earliest buildings erected in the country for the sole purpose of showing films.

Whilst Victorian visitors were happy enough to stroll along the promenade, walk in the gardens or sit in deck chairs on the beach, the 20th century saw much more of an appetite for all manner of amusements, with fun fairs, amusement arcades, and what some might describe as the more garish aspects of commercialism.

By contrast, Southtown and Gorleston remained relatively small and undeveloped until the 19th century. Southtown was the fashionable place of residence for many

Yarmouth merchants, while Gorleston was a fishing village. By the early 20th century, Gorleston had begun to cater for holidaymakers, too, but promoted itself very much as the 'quieter alternative' to Great Yarmouth. After the Second World War, it expanded rapidly with new housing to replace the capacity lost in Yarmouth.

Yarmouth has had its fair share of trials and tribulations over the last century. The Britannia Pier Pavilion has suffered several major fires, and during the First World War, in 1915, the town was one of the first places in Britain to be bombed by Zeppelin airships. During the Second World War, the damage to the town was significant; bombing from over ninety air raids caused major destruction, levelling large sections of the Rows, as well as industrial targets. St Nicholas's church lost its spire and was completely gutted after being hit by incendiaries in 1942. In all, over two hundred people were killed.

In 1953, Yarmouth suffered along with the rest of the east coast during the worst flooding of the century. Hurricane force winds combined with a high tide to break through numerous sea defences all along the coast. In Yarmouth, nine people lost their lives, and thousands were evacuated to local holiday camps while the damage was repaired.

Sadly, post-war redevelopment was largely unsympathetic, a result of the urgent need for extra housing to replace that lost to the war and slum clearance. The 1950s saw the damage wrought by the war cleared away, and blocks of flats put up in place of the old Rows houses, while further development in the 1970s established a new road system and town centre. So it was that much of historic Great Yarmouth was swept away.

In the 1960s, a new industry began to take off. It is ironic, perhaps, that not only is the North Sea the source of one of the finest foods you can eat, but it also provides the means to cook it. The new industrial activity originally started as a search for oil, but whilst there was little to be found, gas was there in abundance. As a result, the port facilities were expanded and improved to service the burgeoning industry. Today, Great Yarmouth is one of the largest offshore marine bases in Europe.

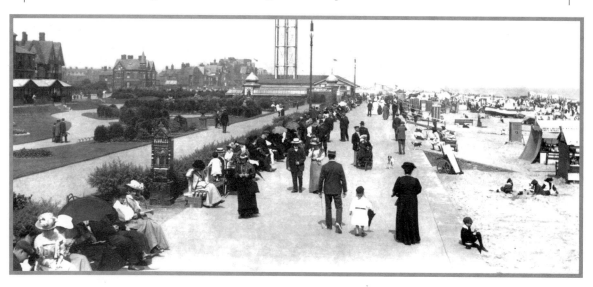

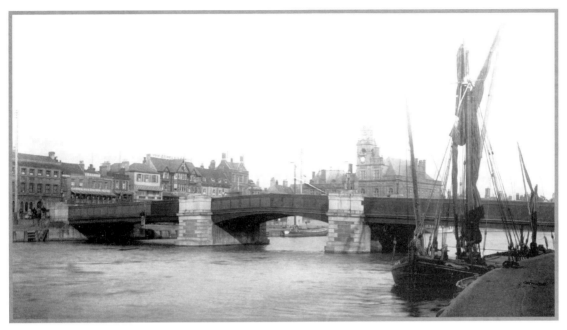

HAVEN BRIDGE 1896 37953

With the tower of the Town Hall overlooking it in the background, Haven Bridge joins Great Yarmouth (on the far bank) with Southtown (on this side). The centre sections lift up to allow the passage of boats. It was replaced in 1930 at a cost of £200,000.

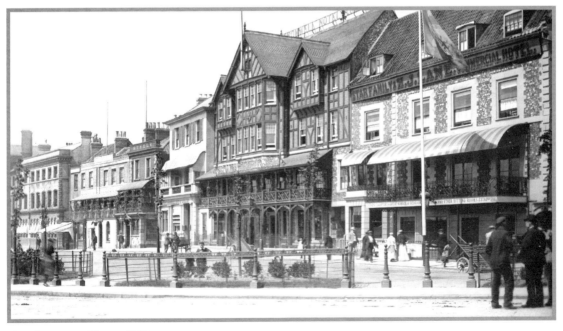

THE CROMWELL HOTEL 1896 37952

Here we see a wonderful mix of building styles on Hall Quay. The Cromwell Hotel is mock Tudor, while the Star Hotel next door has a typically Norfolk facade of dressed flint. Note the extravagant use of decorative wrought ironwork.

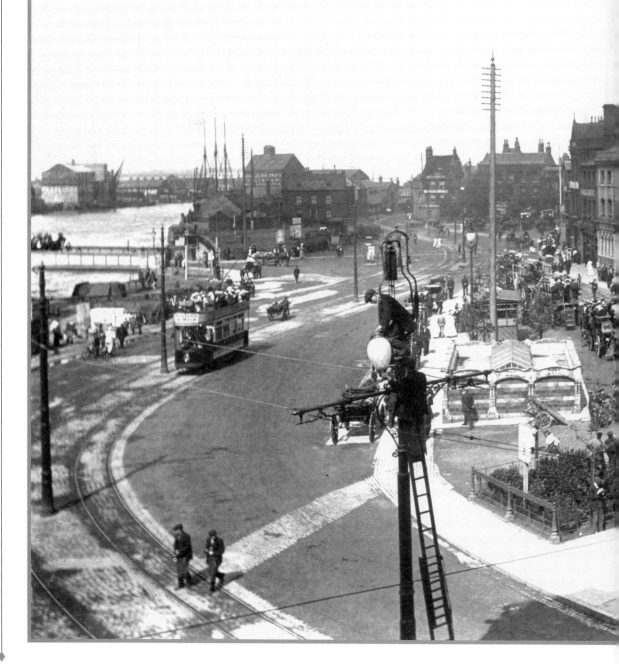

HALL QUAY 1908 60652
This photograph looks down from the Town Hall along
Hall Quay. The intervening years have seen the
introduction of trams to Yarmouth. In the foreground,
two workmen up a ladder are mingling with the
tramline's power cables to repair the street lamp on top.

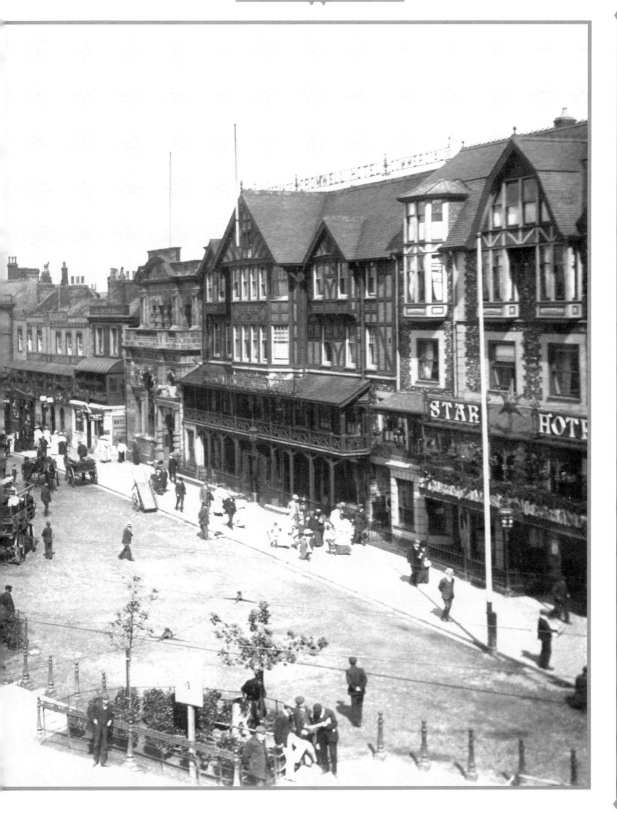

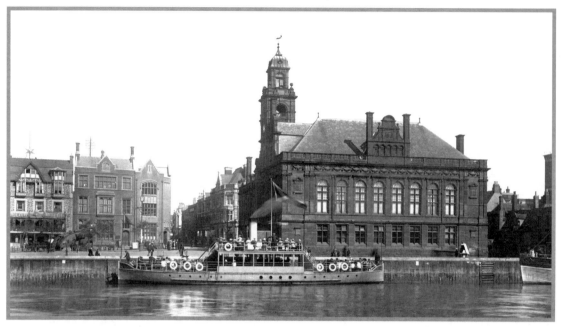

THE TOWN HALL 1922 72535

A pleasure steamer ties up at Hall Quay, with Yarmouth's imposing Town Hall behind. Just visible in front of the Star Hotel and Post Office on the left is a First World War tank, presented to the town in 1919, but removed just four years later, probably for scrap.

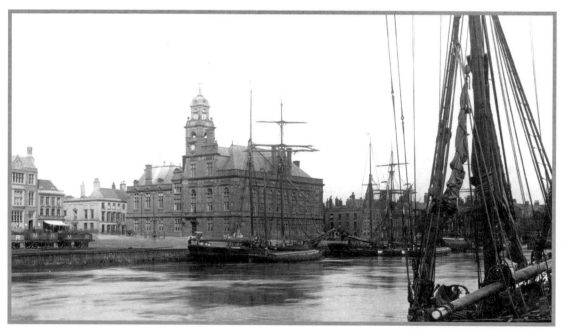

THE TOWN HALL 1891 28699

With their timber hulls, tall masts and rigging, these ships moored at Hall Quay demonstrate the elegance of the age of sail, although at the time of this photograph they would have been considered as merely humble cargo ships. Note the railway carriages on the quayside.

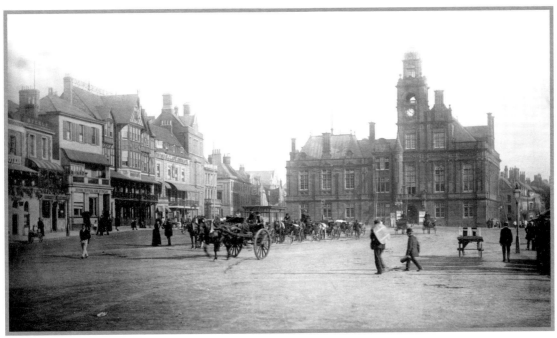

THE TOWN HALL 1891 G56501

Yarmouth's Town Hall was built in 1882, replacing an earlier and undeniably more elegant building which stood on the same site. The area in front is Hall Quay; just out of view to the right is the quayside itself.

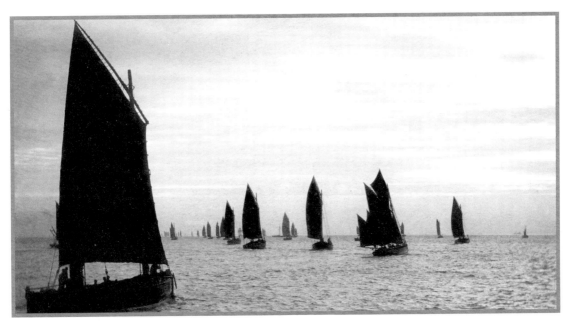

SCOTTISH FISHING BOATS c1900 G56507

The late 19th century saw a huge impact on Yarmouth's fishing industry with the annual migration of hundreds of fishing boats from Scotland, arriving for the autumn fishing season. By 1900, the next revolution was already under way, when steam drifters would land record catches - in 1913, over a thousand vessels landed a total catch of 157,000 tons, which sold for around £1m.

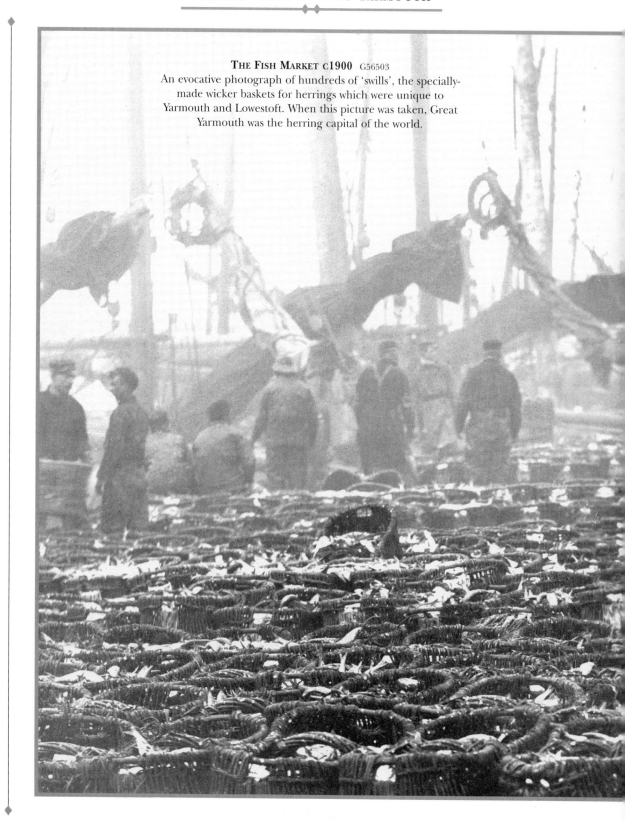

THE FISH MARKET c1900 G56503
An evocative photograph of hundreds of 'swills', the specially-made wicker baskets for herrings which were unique to Yarmouth and Lowestoft. When this picture was taken, Great Yarmouth was the herring capital of the world.

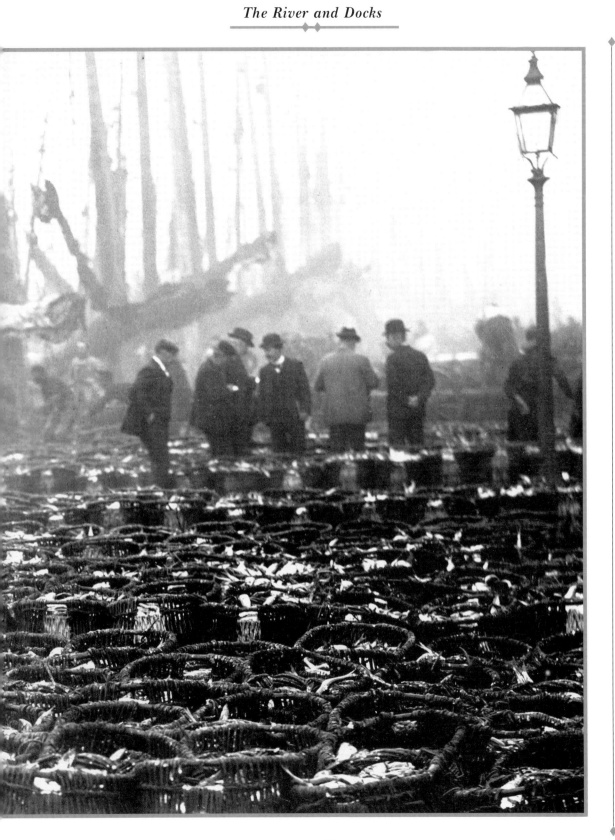

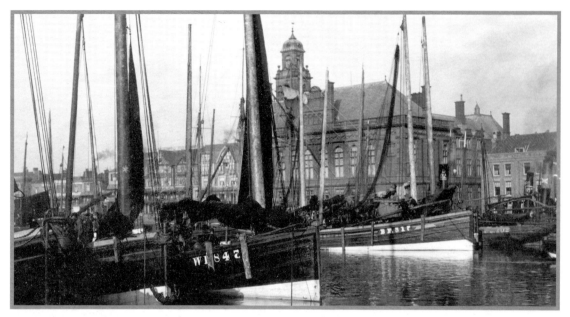

THE HARBOUR c1900 G56510

An interesting blend of the old and the new can be seen in this photograph: fishing boats are moored in front of Yarmouth's town hall. The boats in the foreground are sail, while further back are some steam drifters. At times the harbour would be so jam-packed, it would be possible to cross from Yarmouth to Southtown on the other side of the river simply by climbing from one boat to another!

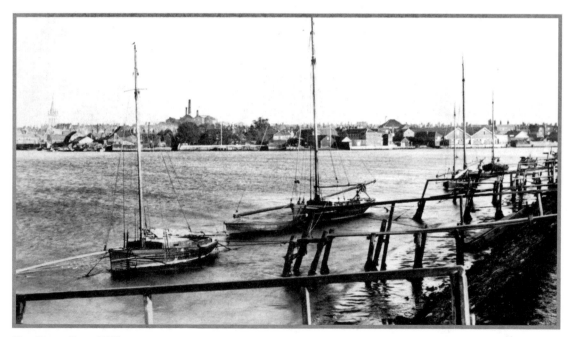

THE RIVER YARE 1887 19873

Sailing boats are at their moorings on the River Yare at the eastern end of Breydon Water. On the far side is Yarmouth, with the spire of St Nicholas's church on the left, and the river bank curving round to North Quay and Haven Bridge on the right.

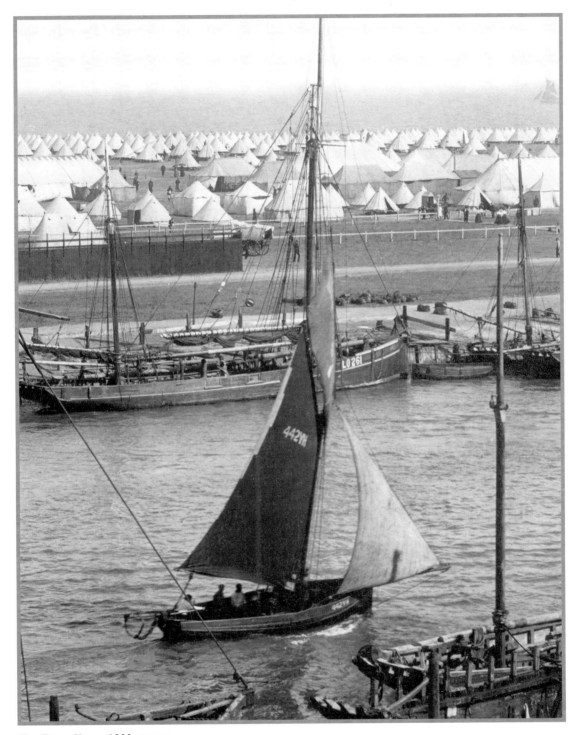

THE RIVER YARE c1900 G56506
Sailing drifters are moored on the River Yare. The opposite bank is South Denes, where an early tented holiday camp has been erected on the race course. It was only after the Second World War that caravans replaced tents. Today all of this land is covered with industrial buildings.

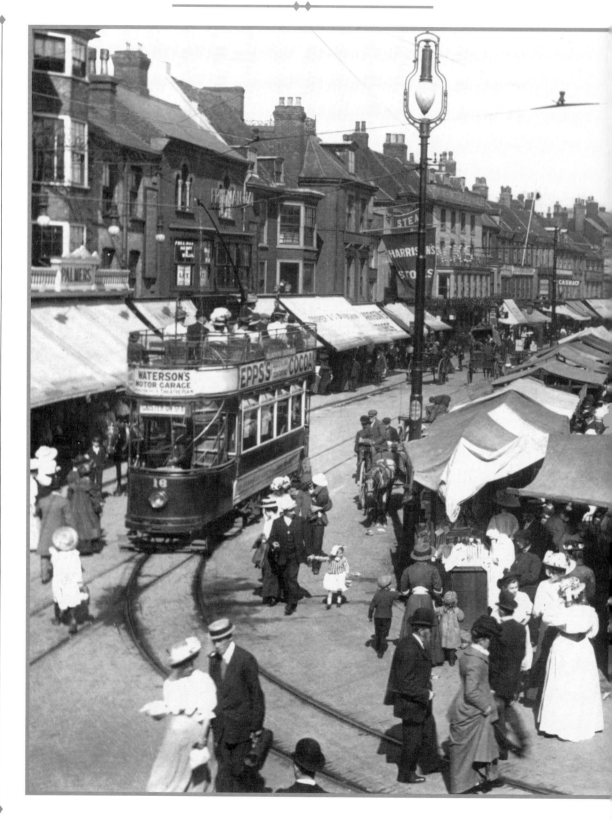

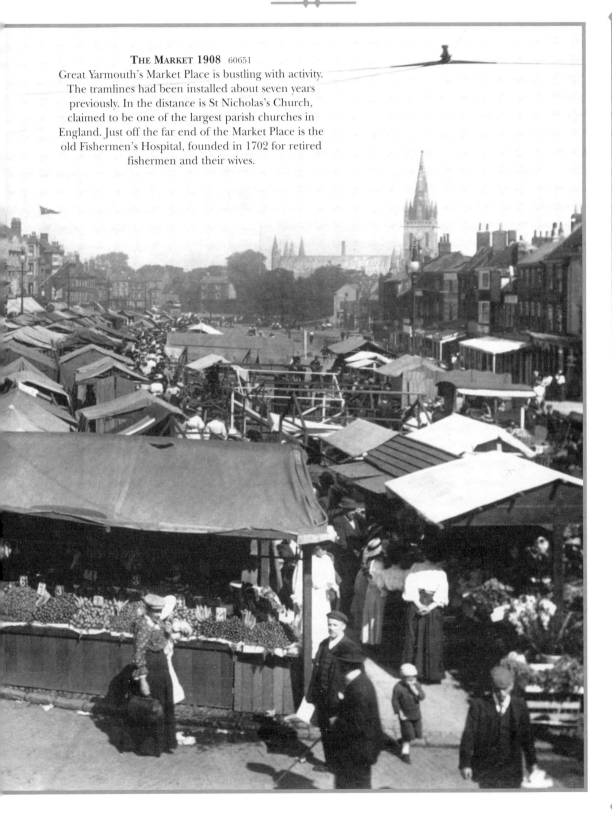

THE MARKET 1908 60651
Great Yarmouth's Market Place is bustling with activity.
The tramlines had been installed about seven years
previously. In the distance is St Nicholas's Church,
claimed to be one of the largest parish churches in
England. Just off the far end of the Market Place is the
old Fishermen's Hospital, founded in 1702 for retired
fishermen and their wives.

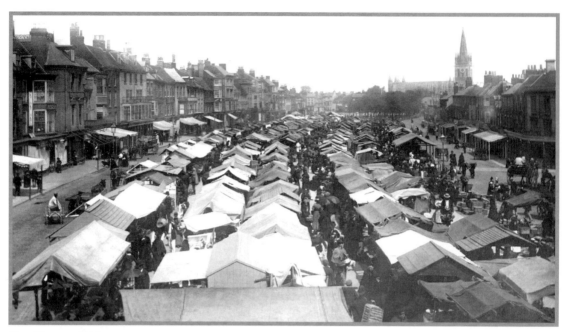

THE MARKET 1891 28716

Here we see the familiar awnings of the Market, with the spire of St Nicholas in the background. The roads on either side appear to have a fairly informal blend between traffic and traders. This was somewhat more clearly defined just over ten years later on, when tram lines were laid along the west side.

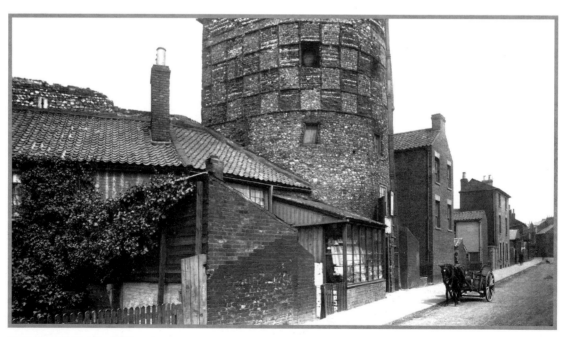

BLACKFRIARS TOWER 1891 28710

In medieval times, Great Yarmouth was walled on three sides, with just the river side open. In modern times, long stretches of the wall still remain, but before the heavy bombing of the Second World War there would undoubtedly have been more. The South-East, or Blackfriars Tower had a distinctive D-shaped section, and was built around 1340.

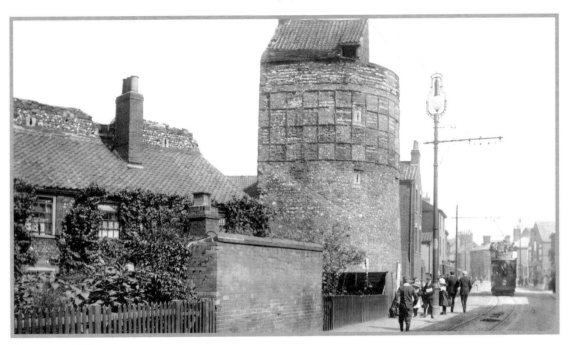

OLD TOWN 1908 60653

OLD TOWN 1908
A tram makes its way along Blackfriars Road, overlooked by the South-East Tower. The houses on the left, which had been built against the town's medieval wall during the latter part of the 19th century, were demolished in the early 1970s, leaving an open grassy area in front of the wall.

◆

NORTH TOWER 1891
When Yarmouth's town wall was finished in the 14th century, there were sixteen towers like this. The walls were twenty-three feet high and seven feet thick, and there were ten gates to provide access.

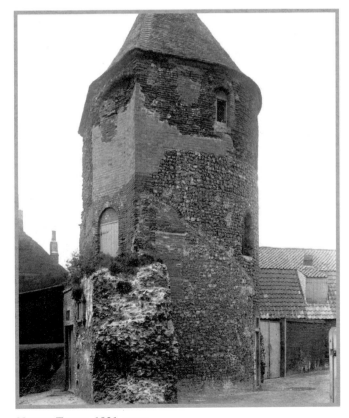

NORTH TOWER 1891 28708

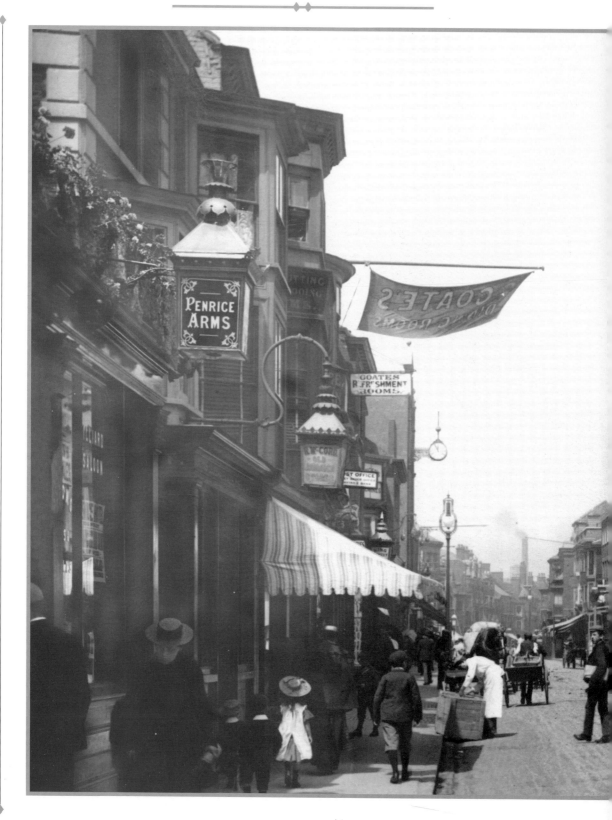

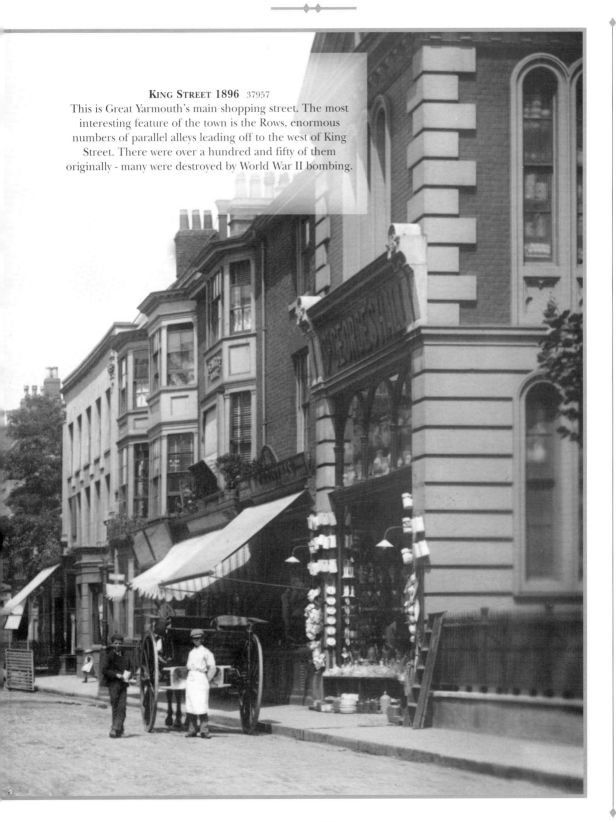

KING STREET 1896 37957
This is Great Yarmouth's main shopping street. The most
interesting feature of the town is the Rows, enormous
numbers of parallel alleys leading off to the west of King
Street. There were over a hundred and fifty of them
originally - many were destroyed by World War II bombing.

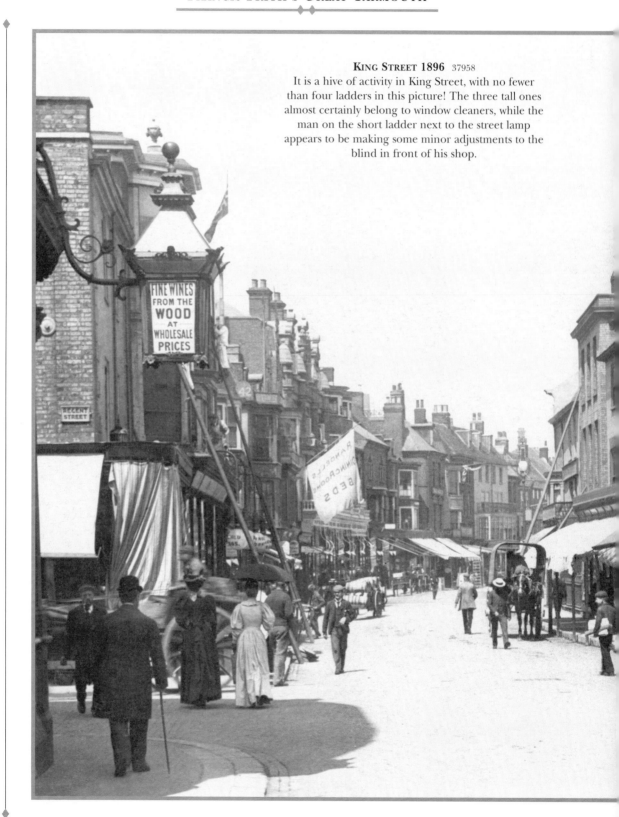

KING STREET 1896 37958

It is a hive of activity in King Street, with no fewer than four ladders in this picture! The three tall ones almost certainly belong to window cleaners, while the man on the short ladder next to the street lamp appears to be making some minor adjustments to the blind in front of his shop.

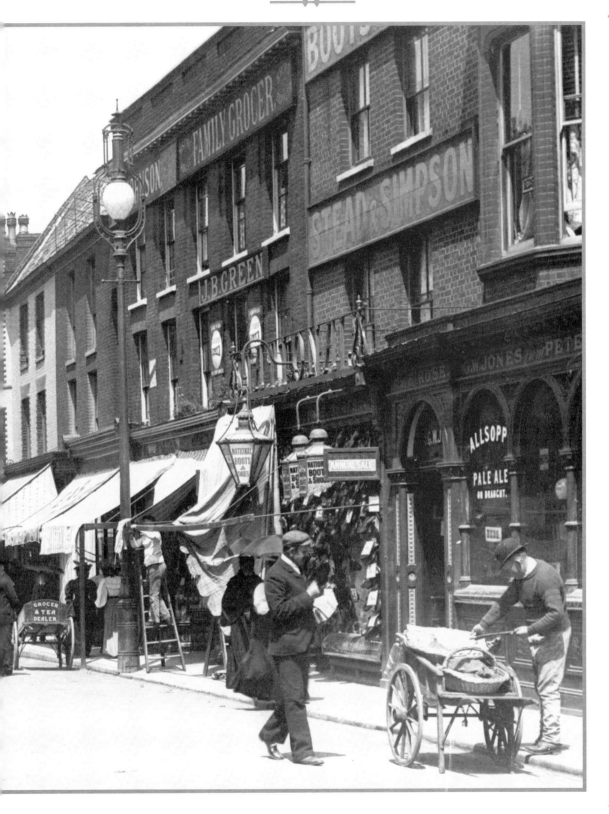

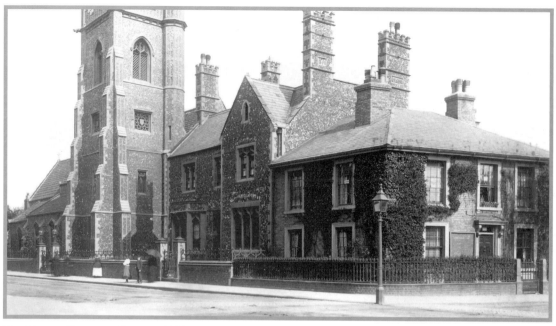

THE ROMAN CATHOLIC CHURCH 1891 28724

The Roman Catholic Church in Regent Road was built in the perpendicular style in 1850. Previously, Catholics had assembled for worship in a room in Howard Street. Next door, the large building on the corner with Nelson Road is Albert House. The Savoy restaurant now occupies the site.

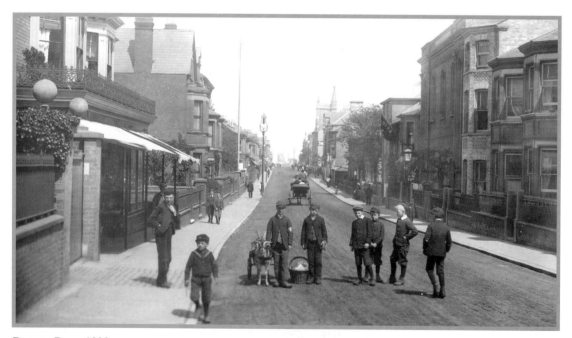

REGENT ROAD 1896 37959

Youths pose for the camera in Regent Road. One of them is holding on to a goat, which would have been used for rides on the beach. In the distance is the tower of the Roman Catholic church. Along the road on the left is where Docwra's famous rock-making factory was established.

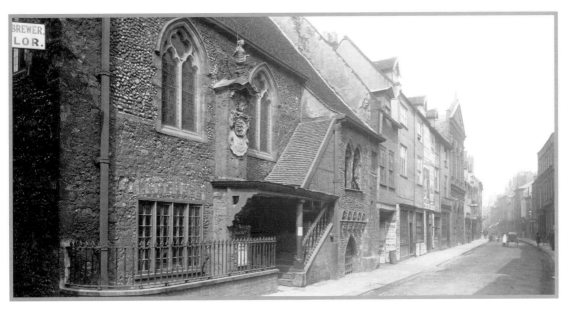

THE FREE LIBRARY 1891 28703

THE FREE LIBRARY 1891

Before its restoration in 1883, the impressive flint-built Tolhouse had been home to the police. It was built in the 13th century, and it served as town hall, court and gaol for six hundred years. In 1645, Matthew Hopkins, the infamous Witchfinder General, condemned sixteen women as witches, and they were held here before their execution. The grated window at street level is the window of the dungeon. These days, the Tolhouse is a museum.

Row No. 60 1908

Unique to Great Yarmouth, the Rows were numerous parallel narrow alleyways which ran from east to west between the Market Place and King Street on one side, and the Quays along the river on the other. They were originally named, but were designated with numbers in 1804. At first they were surfaced with gravel, and then with cobbles or flagstones, and were so narrow that goods had to be transported along them on specially-designed horse carts called trolls. There were over one hundred and fifty rows originally, but intensive bombing in both world wars and subsequent redevelopment has reduced that number to less than half.

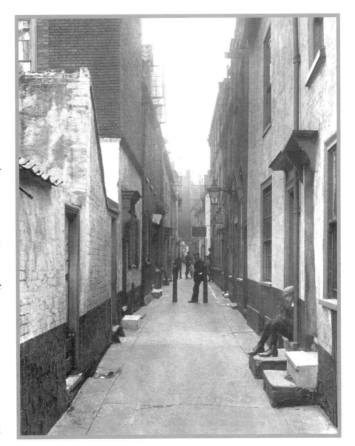

Row No. 60 1908 60654

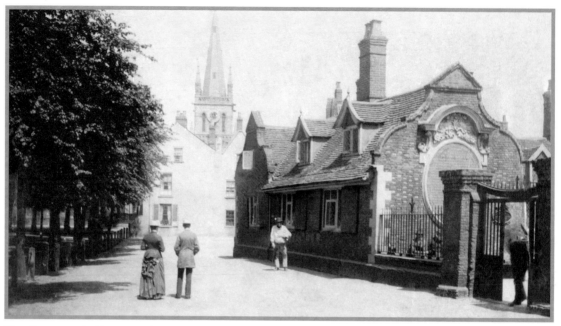

THE FISHERMEN'S HOSPITAL 1896 19896

Just off the end of the Market Place on Church Plain is the Fishermen's Hospital, founded in 1702, with its delightful dormer windows and Dutch gables. Not in view is its archway topped by a cupola, which houses a painted statue of St Peter. Peering over the rooftops in the background is the spire of St Nicholas's Church.

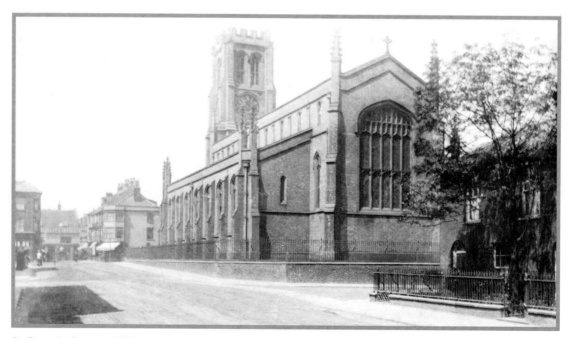

ST PETER'S CHURCH 1896 37969

Dating back to the 1830s, St Peter's claim to fame is that it was the first church in England to suffer bomb damage during the First World War. When St Nicholas's was bombed during the Second World War, St Peter's took over its role. It was subsequently taken over for use by the Greek Orthodox Church.

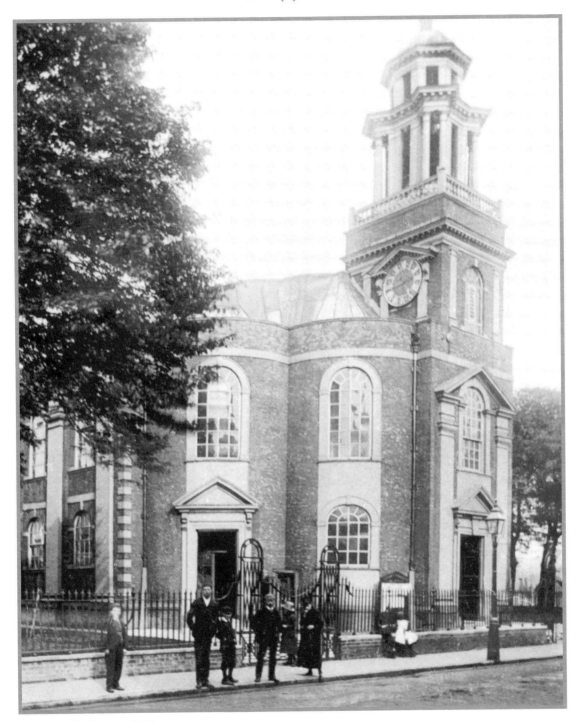

St George's Church 1891 27823
Halfway along King Street is St George's Church. One of the few classical churches in East Anglia, it was built in 1714, modelled on a baroque design borrowed from Christopher Wren, and endowed by a special Act of Parliament. These days St George's is an arts centre. George Borrow, undoubtedly one of the 19th century's most inspired writers, lived nearby at a house in King Street between 1835 and 1855.

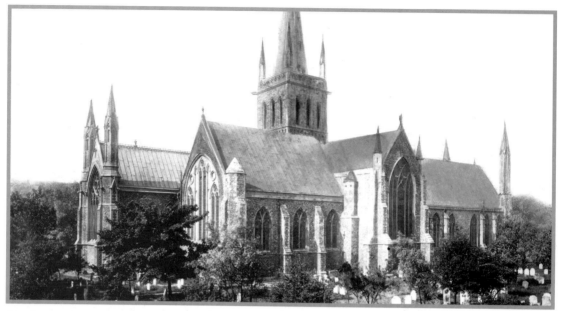

THE PARISH CHURCH FROM THE NORTH-EAST 1896 37962

Built in 1101 by Bishop Herbert de Losinga (also responsible for Norwich Cathedral), St Nicholas's church was originally cruciform, but its shape changed over the centuries into a rectangular one. When this photograph was taken it had recently been extensively restored. It was badly damaged by bombing during the Second World War; although it was rebuilt, it survives today minus the steeple, for so long used as a landmark for passing ships.

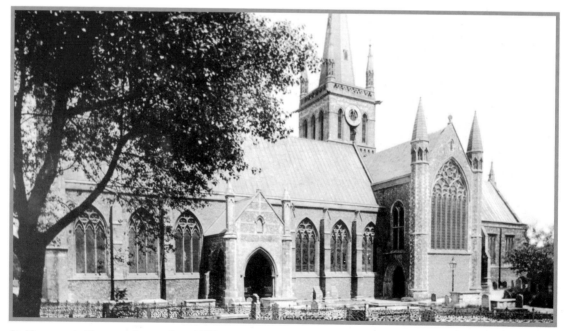

ST NICHOLAS'S CHURCH, SOUTH SIDE 1887 19893

Prior to 1803, the spire of the church appeared crooked whichever way it was viewed, and as it was considered insecure, it was taken down and replaced with a new spire 168ft high. Covered in sheet copper, the spire cost £1890, a considerable sum in those days.

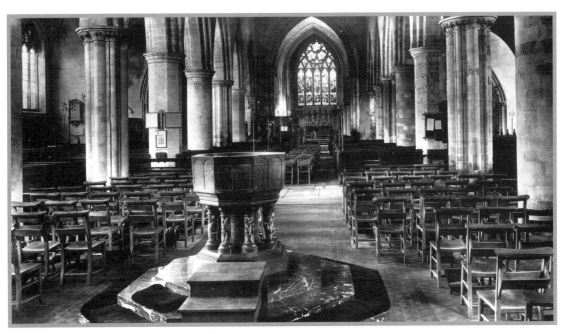

THE PARISH CHURCH, NAVE AND FONT 1896 37965
This view looks up the nave of St Nicholas's (the patron saint of mariners, as well as children and pawnbrokers) from behind the font. The interior of the church was gutted by the incendiary bombs which fell on it in June 1942.

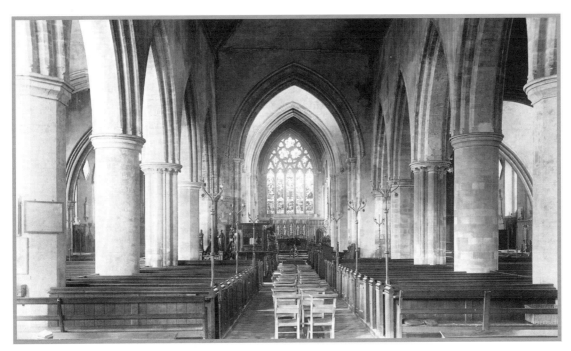

THE PARISH CHURCH, NAVE EAST 1896 37964
Here we are looking along the nave of St Nicholas's towards the altar. The fact that extra chairs run the length of the aisle tends to suggest that services were well attended.

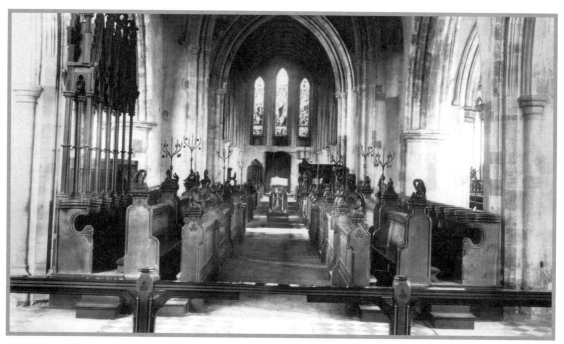

THE PARISH CHURCH, CHOIR WEST 1896 37966
Beautiful carvings adorn the ends of the choir stalls in St Nicholas's church. When this photograph was taken, the church had enjoyed considerable restoration; it is sad that it was all lost less than fifty years later.

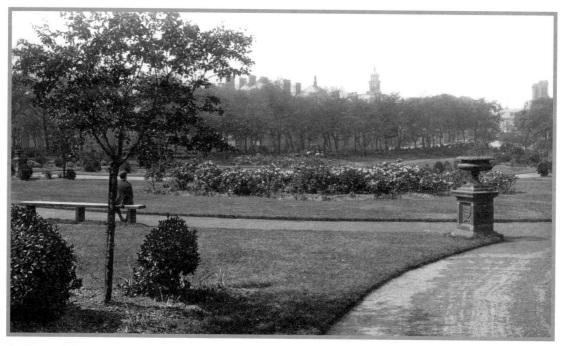

ST GEORGE'S PARK 1896 37971
A moment of peace and tranquillity can be enjoyed in St George's Park. In the background, St George's church can be seen peering over the top of the trees.

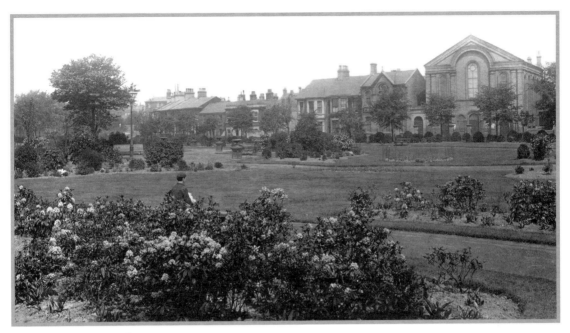

St George's Park 1896 37972

The building on the right is Park Baptist Church; next door, the Men's Room ran Sunday afternoon Bible classes for men of all ages. During the evenings, recreational activities such as billiards and dominoes would be available. The church was demolished in 1990 and a new one built.

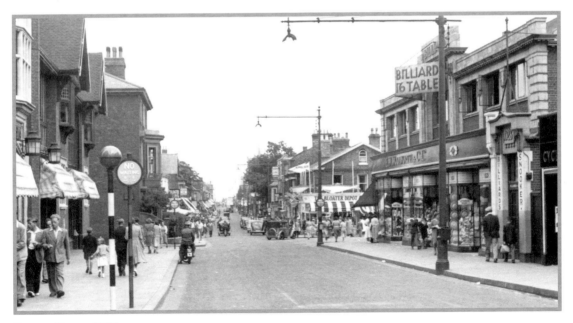

Regent Road c1955 G56039

Running from Marine Parade to King Street, Regent Road combines shops with amusements for the holidaymakers. The billiards and snooker hall, which opened in 1925, is above the Woolworth store. We can see typical fifties fashion on the extreme left: the men are wearing their shirts open-necked, with the collars outside their jacket lapels.

BRITANNIA PIER 1904 52337
Great Yarmouth has two piers, Wellington and
Britannia, both built in the 1850s. The Britannia Pier,
pictured here in 1904, is at the northern end of
Marine Parade, the main seafront thoroughfare.

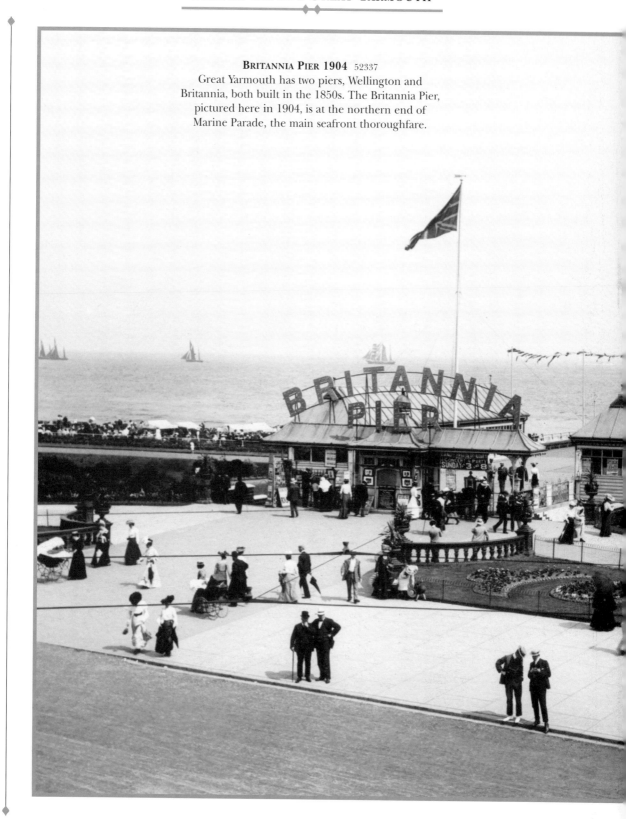

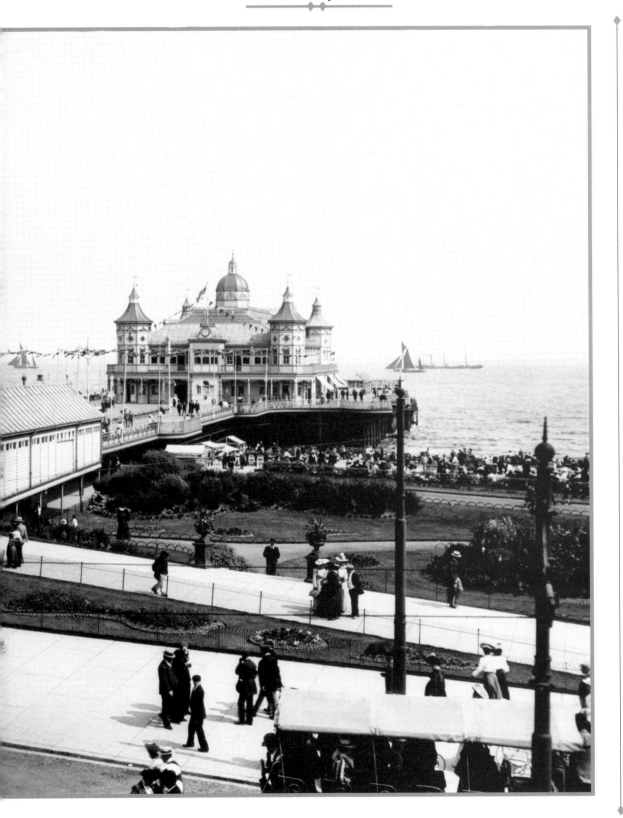

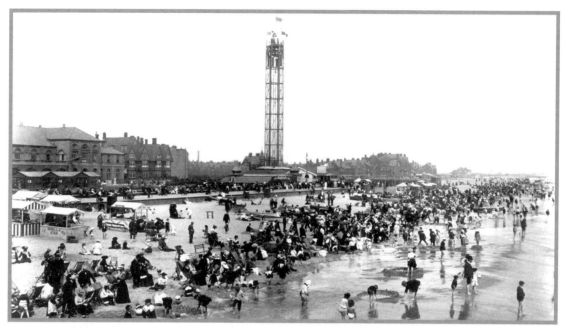

THE SANDS 1904 52333

This sequence of photographs is not in chronological order; rather, it depicts the Revolving Tower in various positions, from the point where the cage is at the bottom taking on passengers to its arrival at the top, one hundred feet above the promenade.

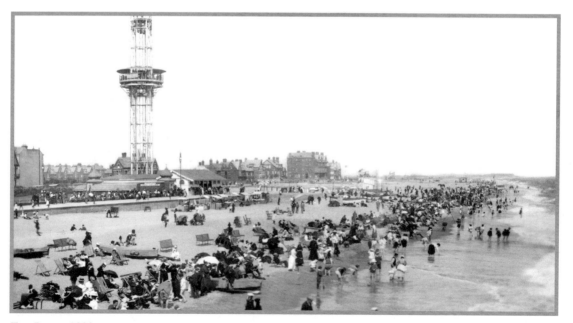

THE BEACH 1899 44496

A closer view of the Revolving Tower, in which people could take a trip up and down in the revolving platform, or stay at the top for a while to soak up the views. There was a refreshment bar at the base of the tower for anyone in need of a mug of hot cocoa after braving the breezes up on top! Barely perceptible in the crowds at the water's edge is a photographer working with a tripod.

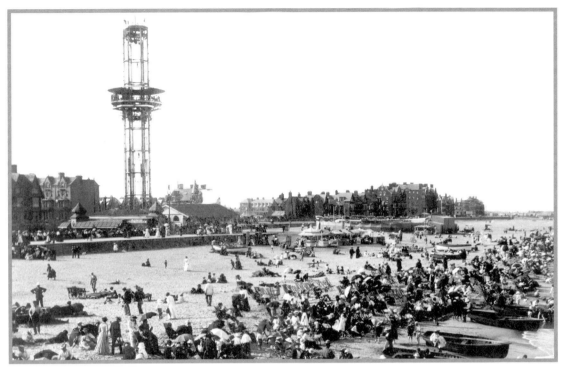

THE BEACH c1900 G56508

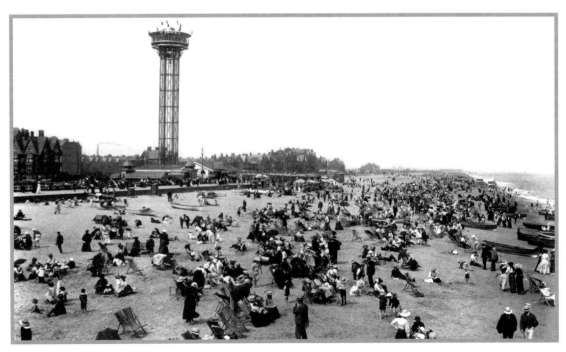

THE BEACH 1904 52332

Ever since the arrival of the railway, Great Yarmouth has been a popular seaside resort, and whilst not the quiet getaway some might prefer, it was always a great pull for working class families from London and the Midlands.

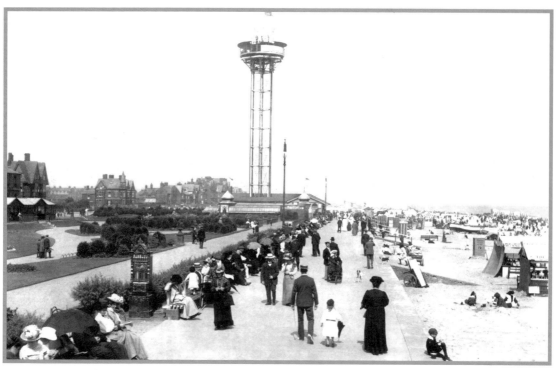

THE PROMENADE 1908 60646

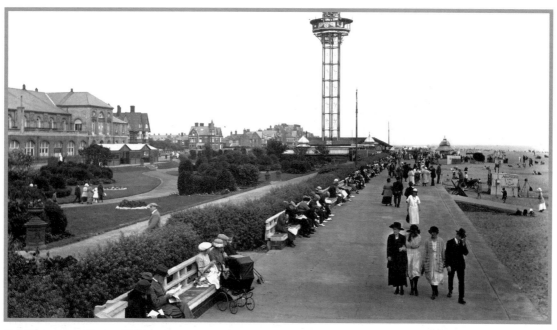

THE REVOLVING TOWER 1922 72518

The tower was torn down for scrap at the start of World War II. Visitors would be lifted slowly in a revolving cage to the viewing platform a hundred feet above the beach, where they could walk about and admire the views over Yarmouth and the surrounding countryside.

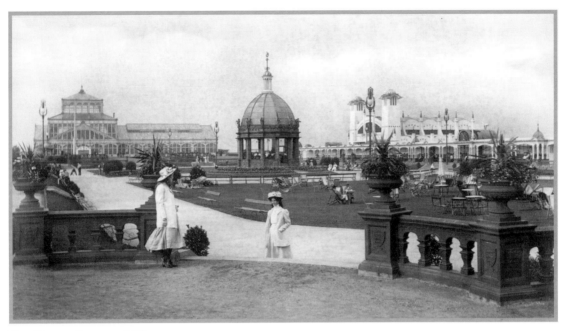

THE WINTER GARDENS 1908 60650

This is just the place for a relaxing walk. The Winter Gardens (the building on the left) embellish the entrance to Wellington Pier, and had been bought at a knockdown price from Torquay, where they had originally been sited from 1878 to 1881. In the foreground, people relax in Wellington Pier Garden, with its fine bandstand.

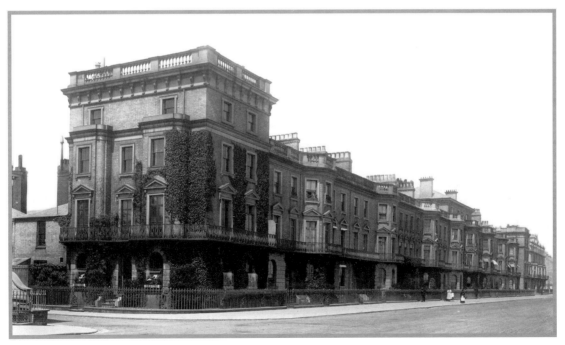

BRITANNIA TERRACE 1891 28700

When it was built in 1848, Britannia Terrace, fronting onto Marine Parade, and beyond that the beach, would have been the pride of the town. By the 1920s most of the houses had been turned into guest houses.

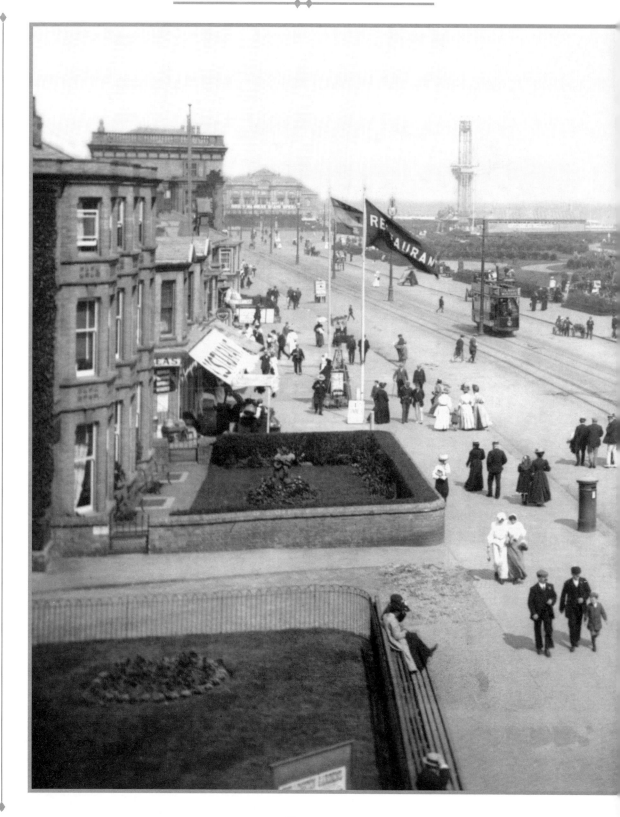

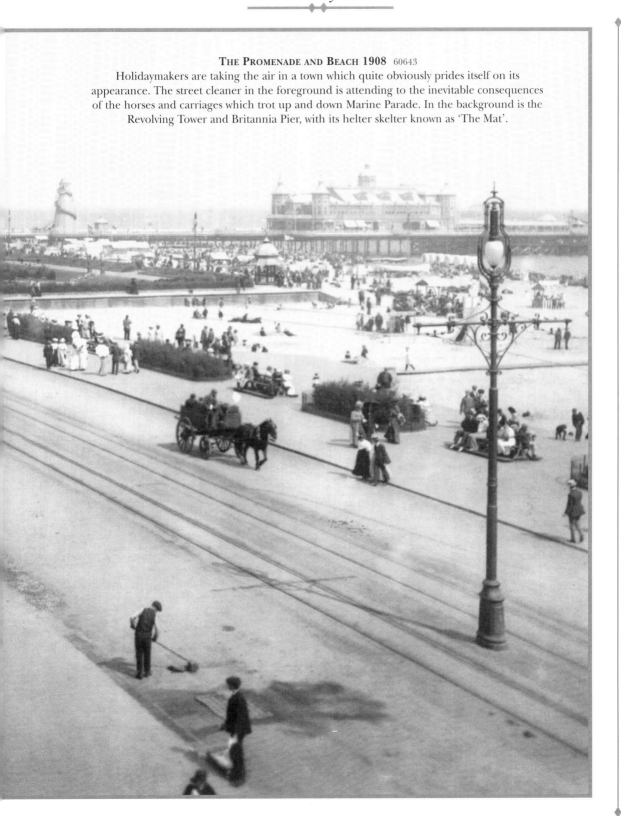

THE PROMENADE AND BEACH 1908 60643
Holidaymakers are taking the air in a town which quite obviously prides itself on its appearance. The street cleaner in the foreground is attending to the inevitable consequences of the horses and carriages which trot up and down Marine Parade. In the background is the Revolving Tower and Britannia Pier, with its helter skelter known as 'The Mat'.

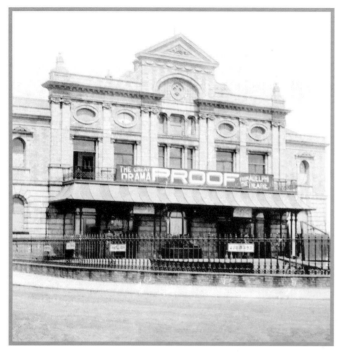

THE ROYAL AQUARIUM 1895 37951

THE ROYAL AQUARIUM 1895 37951
As the name suggests, this building started out in life as an aquarium. It failed miserably and was then converted into a theatre, which hosted everything from West End plays such as the one advertised across the front, to musicals, earning its Royal prefix after gaining the patronage of Edward, Prince of Wales. It was the first theatre in East Anglia to be fitted with a Cinemascope screen.

PONY RIDES c1955 G56030
Here we see the perennial favourite of the seaside - pony rides. While the Royal Aquarium established itself as a theatre and then became a cinema, the building in the background did it the other way round. Opened by Charles 'Cocky' Cochrane in 1908 as the Gem, Yarmouth's first cinema, it became the Windmill Theatre in 1946; its first show featured the up-and-coming comedian Norman Wisdom.

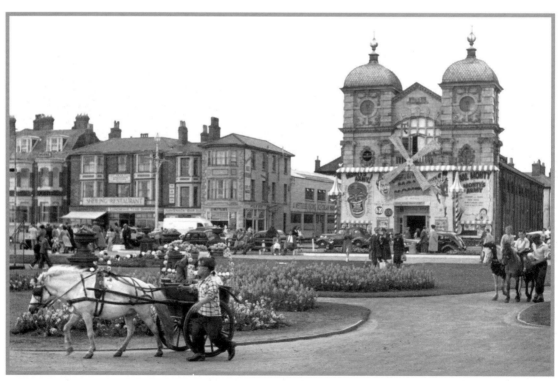

PONY RIDES c1955 G56030

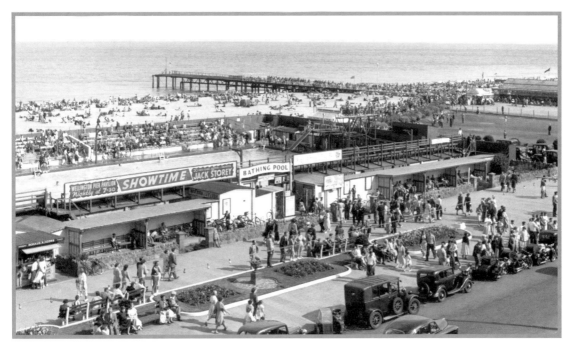

THE BATHING POOL AND THE JETTY c1955 G56041

This view looks down on Yarmouth's open air swimming pool, with the jetty in the background. The facilities were improved around the pool, but subsequently it was all demolished to make way for a new development.

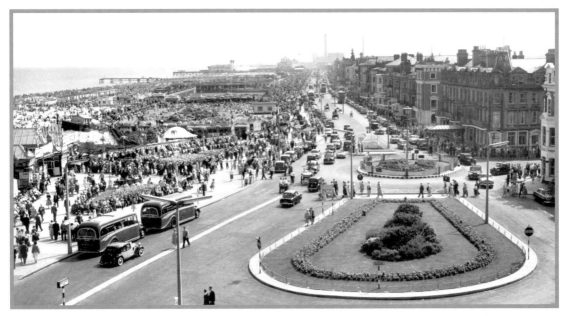

MARINE PARADE c1955 G56069

This view looks south down Marine Parade from the roof of the Royal Aquarium on a busy summer day, most likely a Bank Holiday. In the distance, over a mile away, is the South Denes power station, still under construction, with its 360ft high chimney. Originally designed to burn coal, and later converted to oil, it was demolished in May 1997 in spectacular style with explosives.

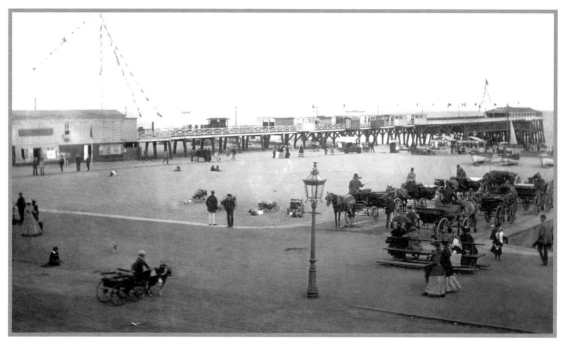

BRITANNIA PIER 1894 33385

Horse-drawn carriages queue up to take holidaymakers for rides up and down Marine Parade. On the left, a lad has a small carriage pulled by two goats - a popular ride for the children.

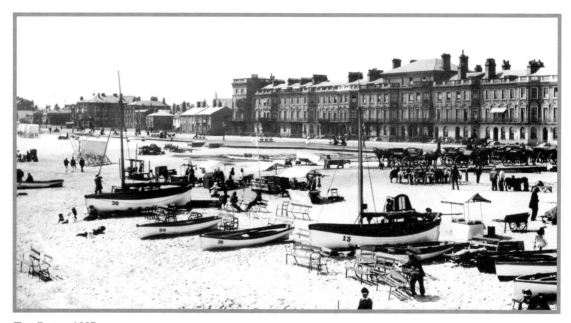

THE BEACH 1887 19860

This photograph shows a fascinating mix of business and pleasure: the boats intermingle with benches for holidaymakers, and to the left in the distance, bathing machines preserve the modesty of anyone taking a dip. In fact, many beach yawls which originally would have serviced cargo ships offshore took to pleasure sailing trips, taking people out to Scroby Sands to look at the seals.

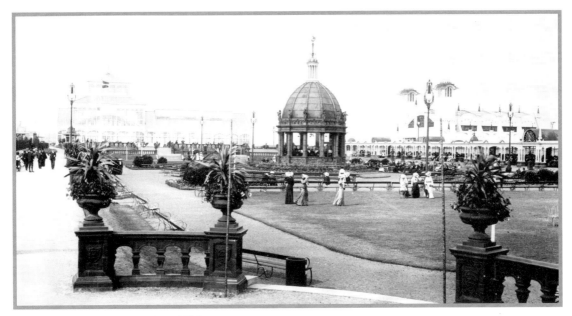

WELLINGTON GARDENS AND PIER 1904 52338

A relaxed atmosphere prevails in Wellington Pier Gardens. The bandstand in the middle was a popular entertainment for locals and holidaymakers alike. Wellington Pier Pavilion was brand new in this picture, erected in just two months the year before, while the Winter Gardens on the left had been brought from their original situation in Torquay at the same time.

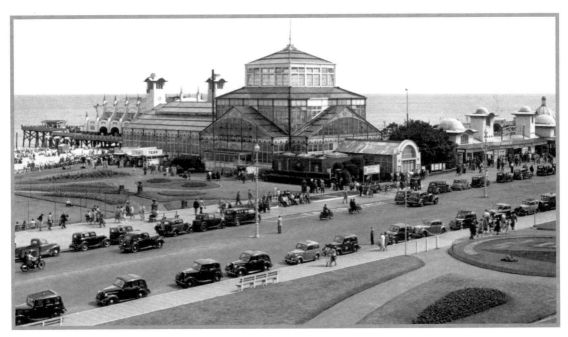

WELLINGTON PIER c1955 G56036

The great iron and glass structure which started out in Yarmouth as Wellington Pier's Winter Gardens has seen one or two changes since it was first brought here from Torquay in 1903. Apart from its original purpose, it has also seen use as a skating rink and beer garden.

THE AMUSEMENT PARK 1908 60647
There is fun galore to be had on Britannia Pier, with
'the Mat', its helter skelter, in the middle. The
wonderfully ornate pavilion at the end of the pier was
built at a cost of £16,000 by the Norwich company
Boulton and Paul in 1902. A year after this
photograph was taken, the pavilion burned down.

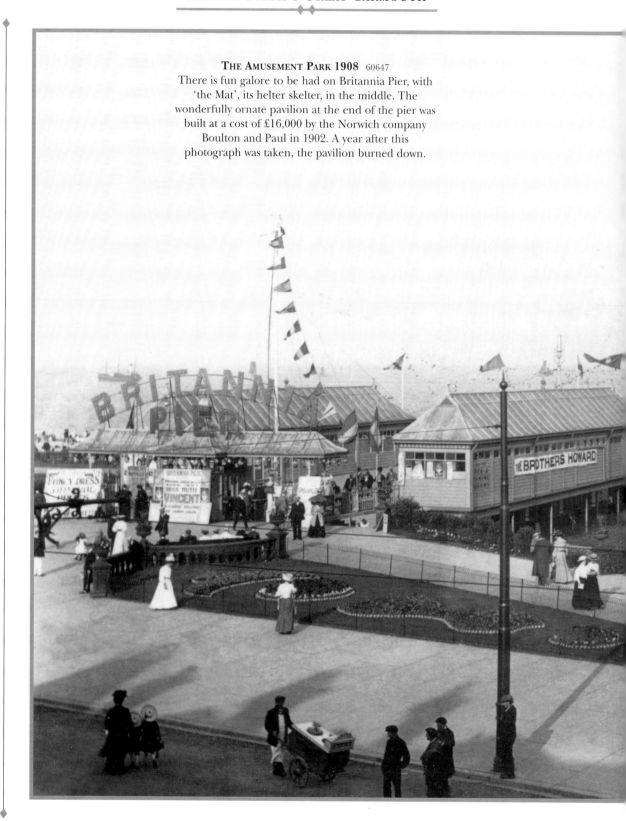

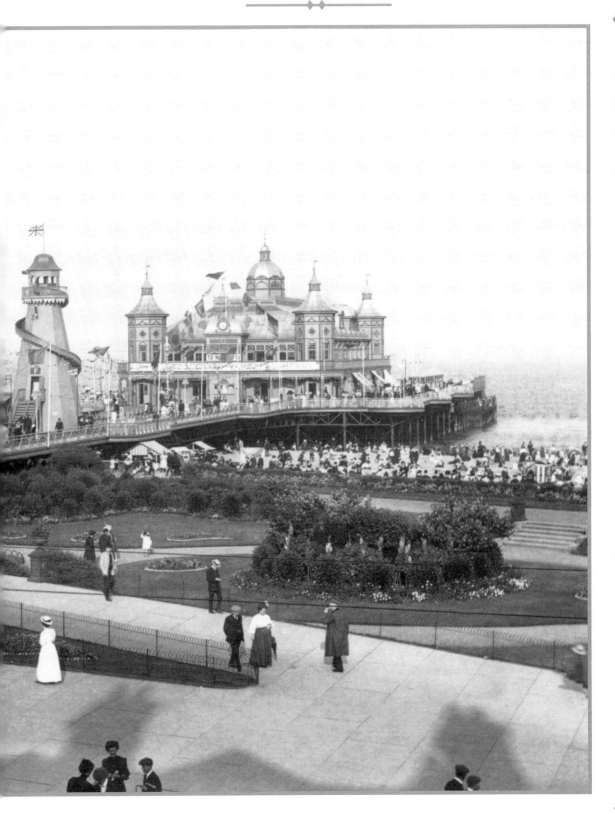

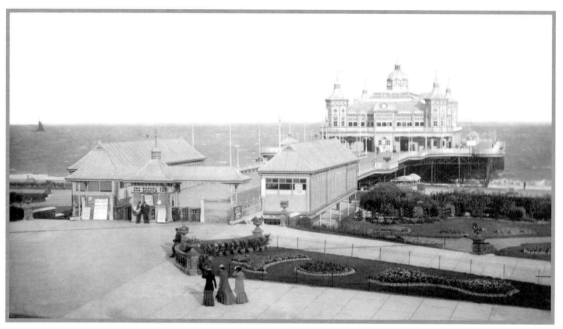

NEW PIER 1902 49072

Britannia Pier was built originally in 1858. It was rebuilt in 1901, with a splendid pavilion sporting a dome and four turrets, which were added the year this photograph was taken. Sad to relate, the pavilion was not to last; it burned down in December 1909.

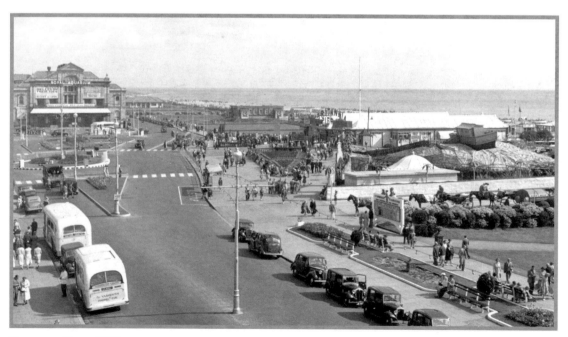

BRITANNIA PIER c1955 G56015

This view looks north along Marine Parade, with the Royal Aquarium to the left, and the entrance to Britannia Pier just across the road on the right. In front of it is a new addition to the attractions at Yarmouth, the Joyland children's amusement park, built in 1951, with the 'Ark' added a year later.

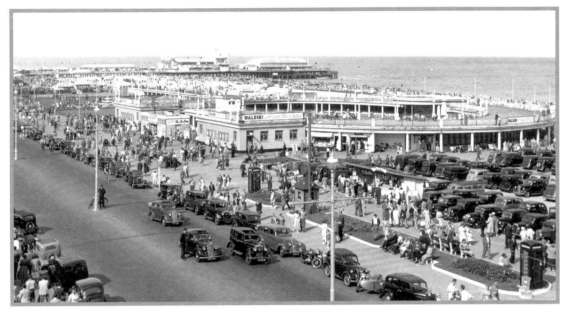

THE MARINA AND BRITANNIA PIER c1955 G56042
There are huge crowds on the front at Yarmouth, and not a single space in the car park! The Marina was an open-air theatre capable of seating up to 4,000, built in 1937 at a cost of £12,000. When this photograph was taken, it would have been popular for concerts and talent competitions. It was demolished to make way for the multi-million pound Marina Leisure Centre, opened in 1981.

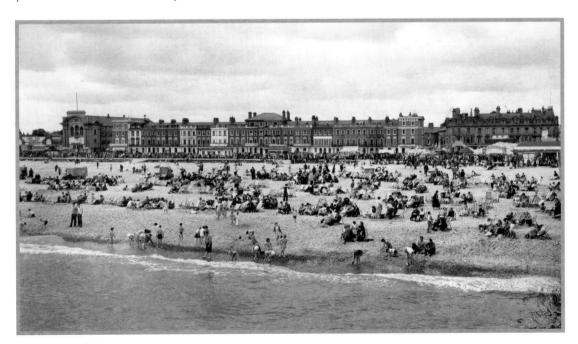

THE BEACH c1960 G56070
Judging by the clouds in the picture and the fully-clothed state of the vast majority of the crowds on the beach, one of the all too frequent chilly breezes is blowing in off the sea. In the background is Britannia Terrace, with the Empire Cinema at the left hand end.

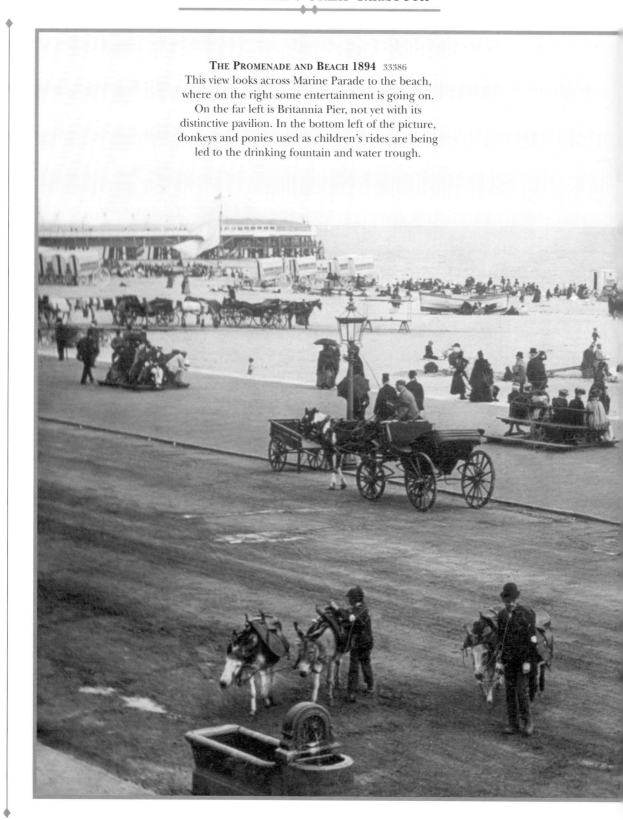

THE PROMENADE AND BEACH 1894 33386
This view looks across Marine Parade to the beach,
where on the right some entertainment is going on.
On the far left is Britannia Pier, not yet with its
distinctive pavilion. In the bottom left of the picture,
donkeys and ponies used as children's rides are being
led to the drinking fountain and water trough.

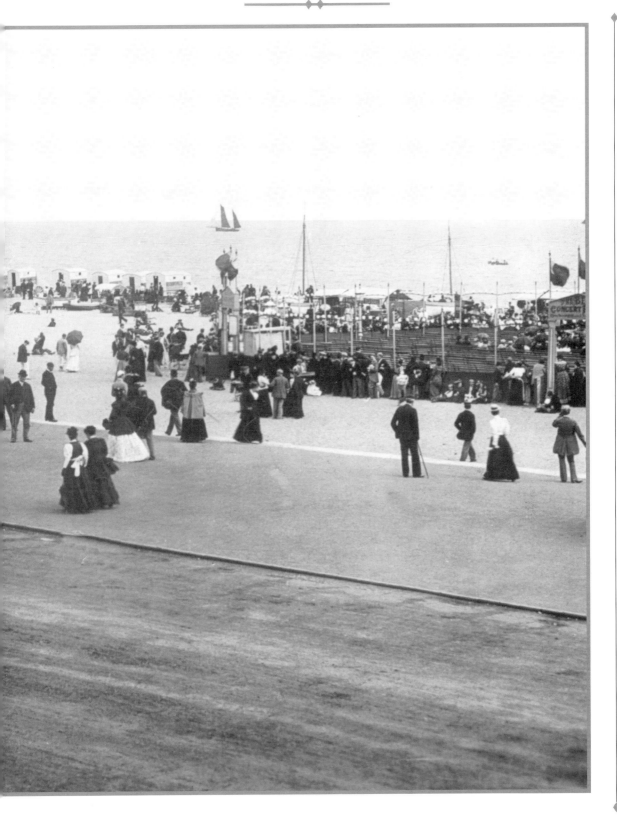

THE JETTY 1908 60648

The 450 feet long jetty was built in 1808, replacing an
earlier one; apart from being a landing place for
boats, it became a popular promenade for visitors
before the two piers were built. When Nelson arrived
in Yarmouth with Lady Hamilton, his boat berthed
here. It was often used as the departure point for
sight-seeing boat trips.

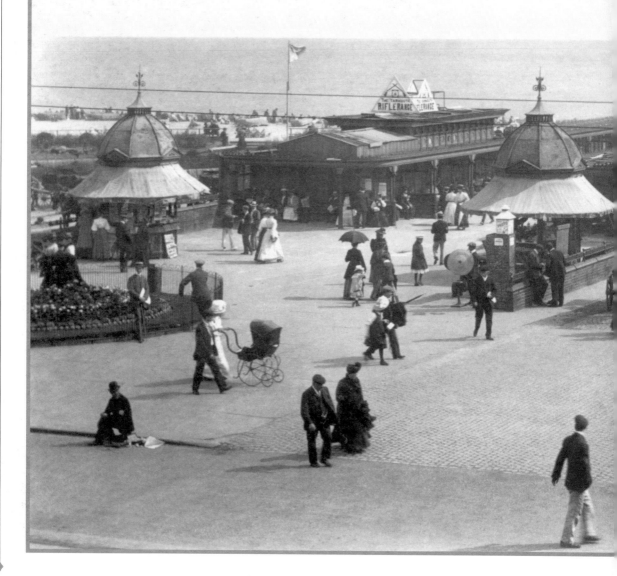

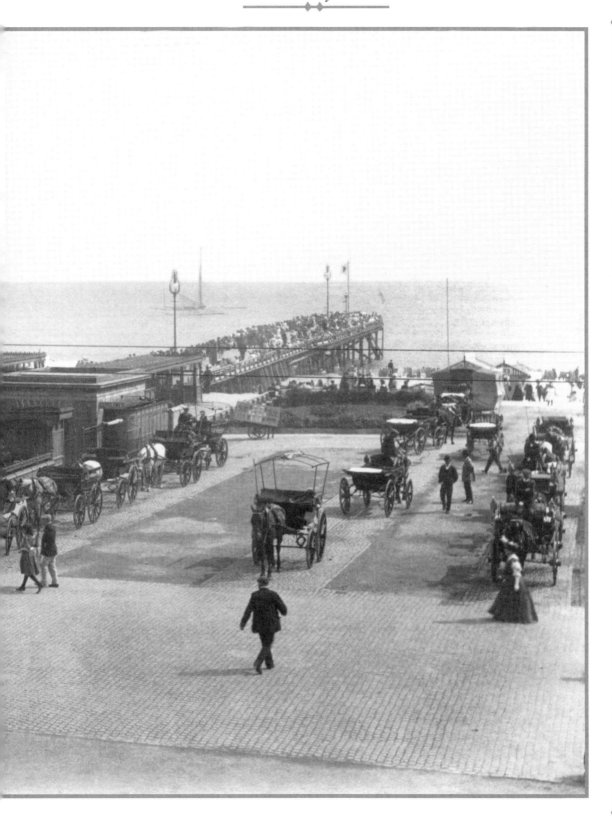

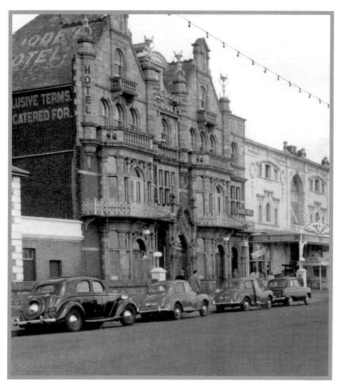

GOODE'S HOTEL c1955 G56058

GOODE'S HOTEL c1955
When John and William Goode took over the Winton Assembly Rooms at the turn of the century, the building looked rather different. It was destroyed by fire in 1901, and was rebuilt in somewhat grander style. The next building along from the hotel was the Paradium in the early part of the century; it was the forerunner of modern amusement arcades, with the added attraction of freak shows!

◆

TRAFALGAR TERRACE 1887
As with many towns and cities, Yarmouth has more than a smattering of streets named after Britain's great military heroes - Wellington, Kitchener and Nelson. But with Nelson's links with Yarmouth, one might expect a little more, which perhaps explains a road, a court, a terrace and even a square all named after Nelson's most famous battle. You could say the foreground features transport for all ages; the horse and carriage on the right for grown-ups, the goat carriage on the left a popular novelty transport for children.

TRAFALGAR TERRACE 1887 19870

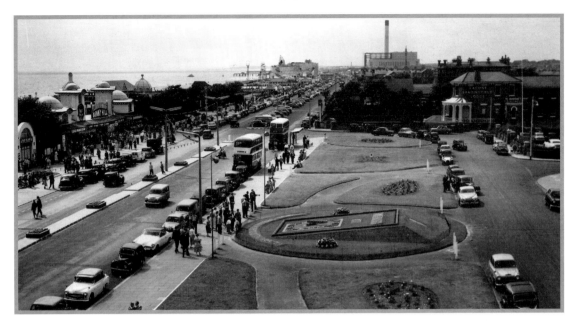

MARINE PARADE AND FLORAL CLOCK G56072

It might not be much use to you if you are on the wrong side of the road and you are out to catch a bus, but the floral clock on the front at Yarmouth always gains appreciation from those who take the time to stop and look. Across the road, comedian Benny Hill is starring at the Britannia Pier. In the distance is Wellington Pier and the power station beyond, with the slender column of Nelson's monument in front.

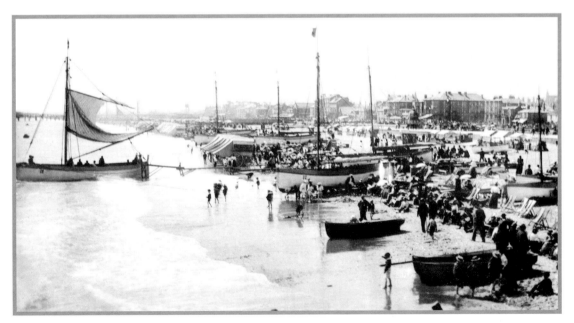

FROM BRITANNIA PIER 1899 44495

This wonderfully chaotic scene appears to have much in common with a modern-day picnic in a car park. The beach yawls would operate sailing trips for holidaymakers, while rowing boats were available as well. Further along the beach there are rows of bathing machines, while in between, fully-dressed holidaymakers cram together in their deck chairs as close as possible to the water's edge.

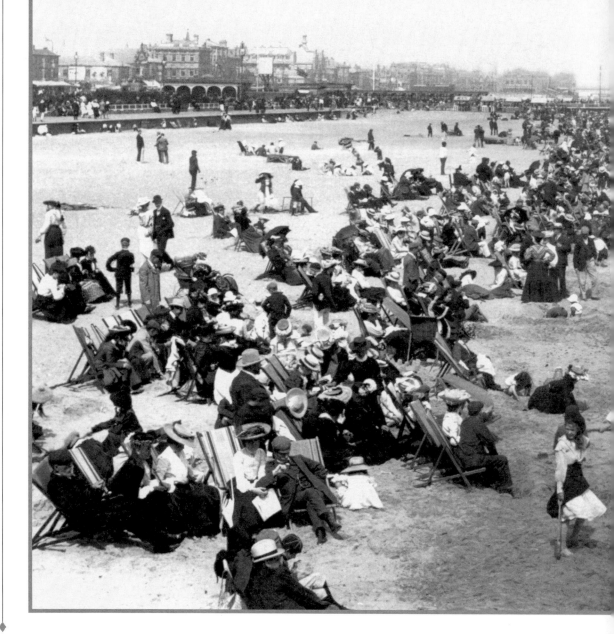

THE SANDS 1904 52335

These days, huge crowds on the beach are more likely
to ensure an even distribution of people throughout.
But in 1904, people were much more attuned to the
invigorating effects of closeness to the sea. They may
not be able to afford to use a bathing machine in
order to take a dip, but they can at least get as close as
possible to the water, and maybe take a paddle.

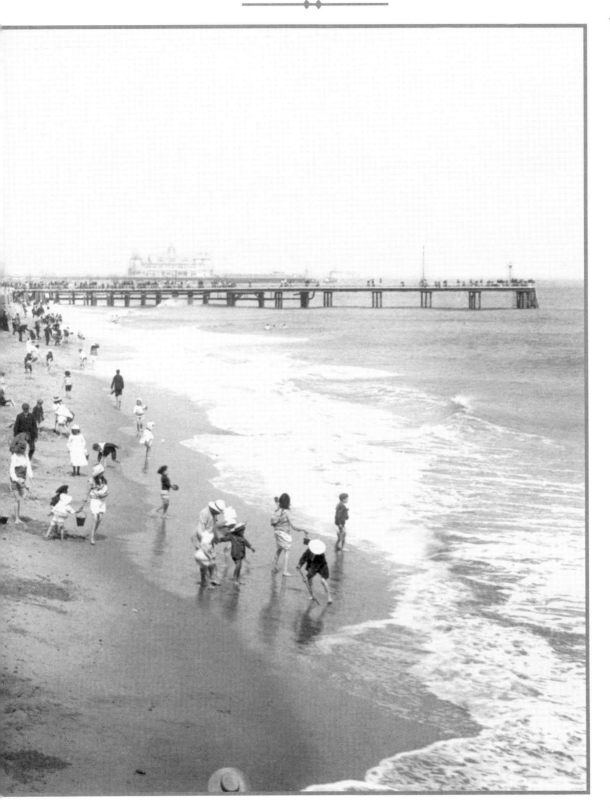

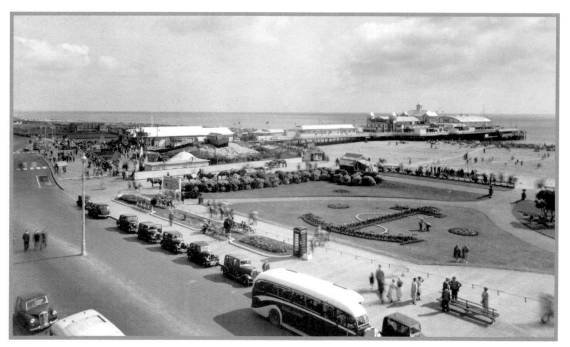

BRITANNIA PIER c1960 G56044
This nice view shows Britannia Pier with the Anchor Gardens in the foreground, taken from a high viewpoint on Marine Parade. As can be seen by the generous spacing of the vehicles, parking is not yet a major problem.

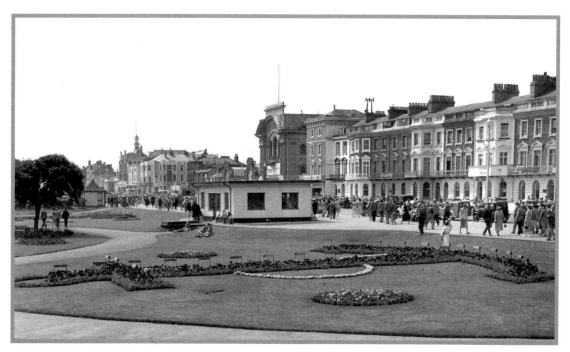

ANCHOR GARDENS c1955 G56025
A busy Marine Parade seen from the Anchor Gardens. The square building in the foreground is a tourist information centre; directly behind it is the Empire cinema, built in 1911.

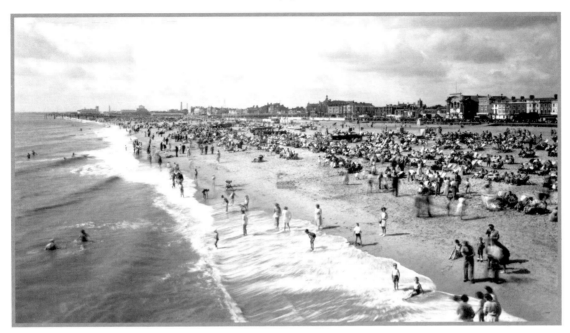

CENTRAL BEACH c1955 G56045

By the mid-fifties, beach-goers were less likely to squeeze together in their deck chairs at the water's edge, and whilst those brave enough to take a dip in the chilly waters are wearing their bathing costumes, it is apparent from everyone else on the beach that the craze for stripping off and sunbathing has yet to take hold.

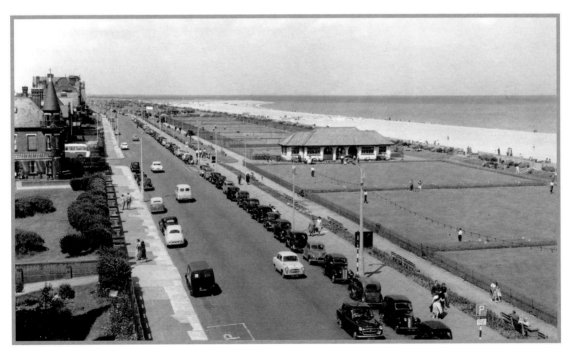

NORTH DRIVE c1960 G56073

North Drive is the continuation of Marine Parade north of Britannia Pier. Bowls addicts are in their element here, with a number of bowling greens laid out between the road and the beach.

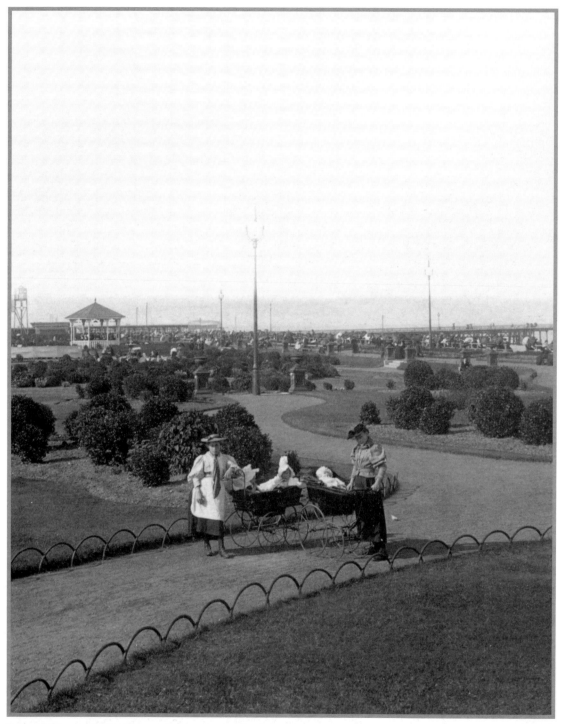

BEACH GARDENS 1896 37948
A distinctly posed photograph in the Beach Gardens north of Wellington Pier, with the jetty to the right. On the skyline, less clearly defined beyond the bandstand and look-out tower is Britannia Pier before its pavilion was built.

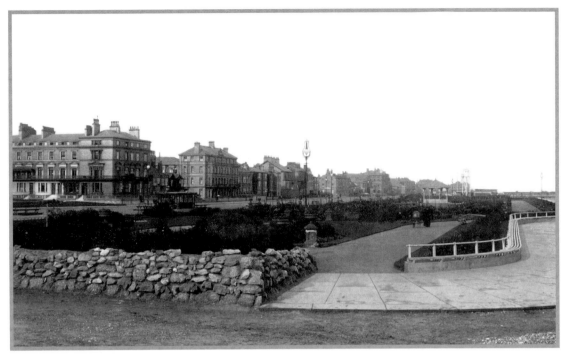

THE GARDENS 1894 34819
This is a quiet moment for a stroll in the Beach Gardens. The lookout tower and jetty are in the distance.

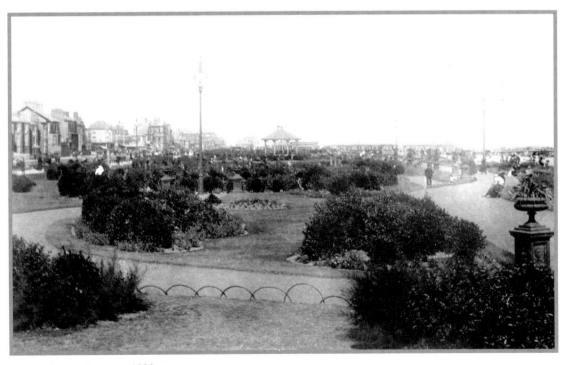

SOUTH BEACH GARDENS 1899 44499
This is five years on from photograph No 34819, and taken a little further into the beautifully-kept gardens.

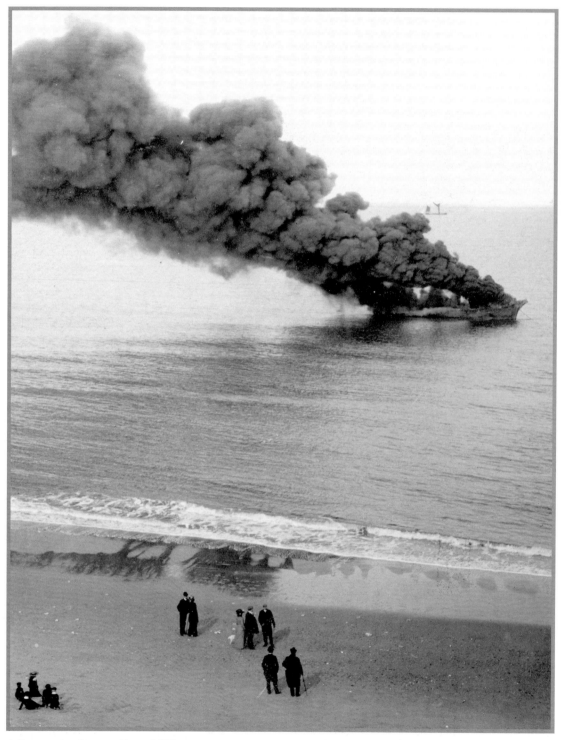

A PETROLEUM SHIP ON FIRE C1900 G56502

The east coast has claimed many ships during storms, but catastrophes can happen even in calm seas. This burning ship is close enough to the shore to attract a crowd of curious onlookers.

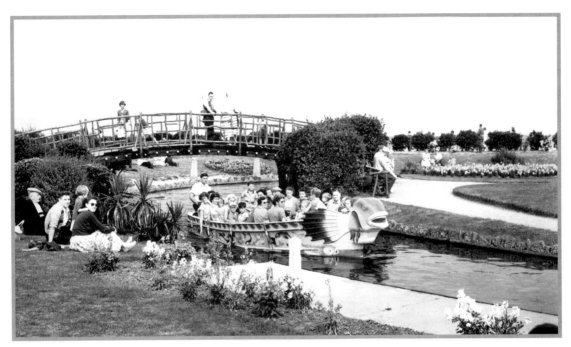

THE WATERWAYS c1960 G56071
When the Venetian Waterways were laid out in the 1920s as an exercise to help provide work for some of the town's unemployed, the boats had not been embellished with large brightly coloured fish!

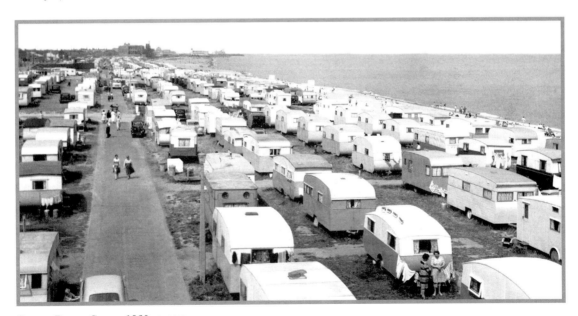

SOUTH DENES CAMP c1960 G56099
Great Yarmouth occupies a spit of land which deflects the River Yare from entering the sea for three miles. South of the main resort, not far from the harbour entrance, is South Denes, now given over to caravan sites. It was an undeveloped sandy heath until the Napoleonic Wars, when a military garrison was erected. The barrack master was Captain George Manby, inventor of the breeches buoy and many other nautical life-saving devices. He also came up with the idea of giving each lighthouse its own unique pattern of flashes.

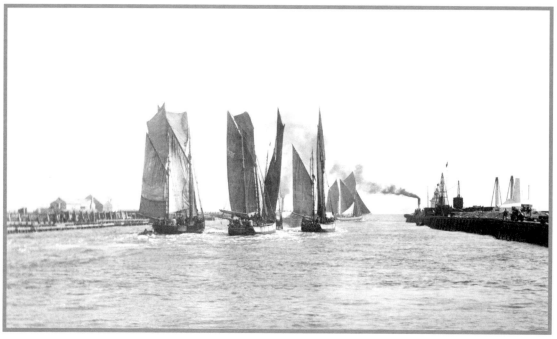

GORLESTON, THE HARBOUR 1894 33393

In 1894, these sailing barges in Yarmouth's harbour entrance would still have been the mainstay for conveying cargo from one port to another. But just as in this photograph, the big takeover by steam was just around the corner.

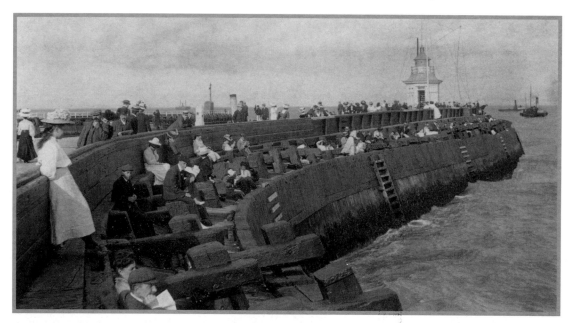

GORLESTON, THE PIER 1908 60662

The sheltered niches in between the protruding timbers, which date from the original harbour's south pier in the 16th century, were known as the 'cosies' - popular sheltered spots for holidaymakers to take the sea air, watch the comings and goings of boats in and out of the harbour, or just to sit and read. They were also a popular place at night for young men and women! Sad to relate, the cosies disappeared when the breakwater was rebuilt in 1964.

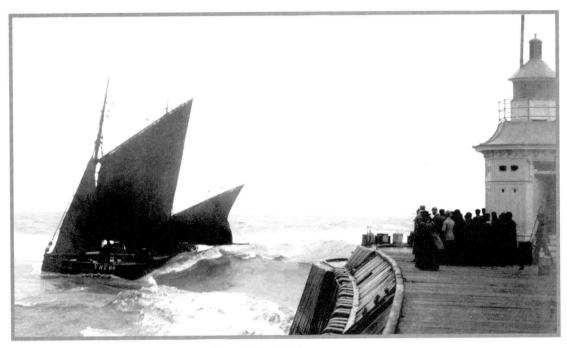

GORLESTON, BOAT COMING IN FROM THE SEA c1900 G56504

A small crowd gathers next to the distinctive pepper-pot lighthouse on the south pier in Gorleston, watching the progress of a fishing boat as it batters through rough seas to the harbour entrance.

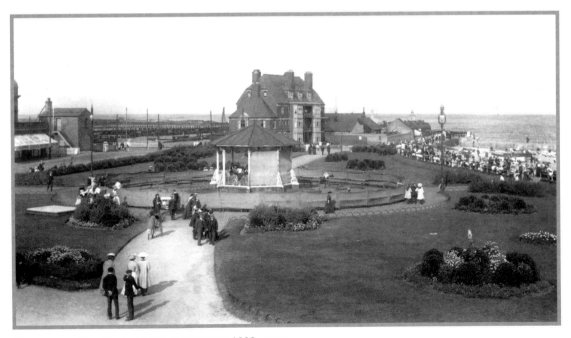

GORLESTON, THE GARDENS AND BANDSTAND 1908 60659

It is a sunny day, undeniably, but perhaps there is a brisk breeze blowing as well, if the screens on the bandstand and seating around it are anything to go by. In any event, the band's playing does not appear to have attracted very many appreciative listeners!

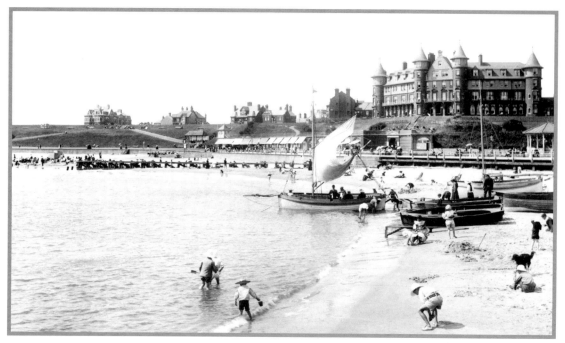

GORLESTON 1904 52329
The newly-built Cliff Hotel dominates this view of the beach at Gorleston. Below it, to the right, is a bandstand, which later made way for an open-air swimming pool.

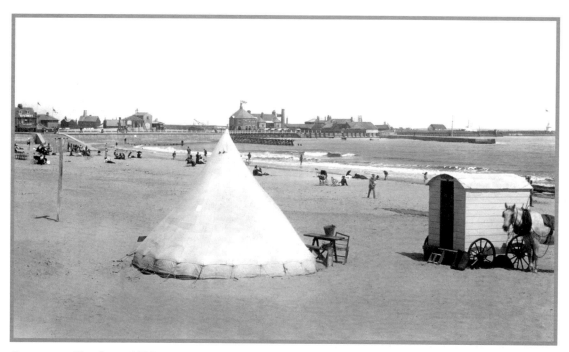

GORLESTON, THE SANDS 1896 37974
In Victorian times, the preservation of modesty was paramount, so bathing machines such as this one were very much the order of the day to allow bathers to change.

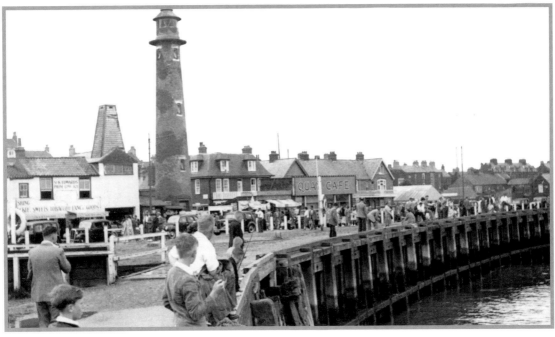

GORLESTON, BRUSH QUAY c1955 G35009

Holiday visitors gather on Gorleston's Brush Quay to watch the comings and goings along the river. Note the lighthouse still in its wartime colour-scheme

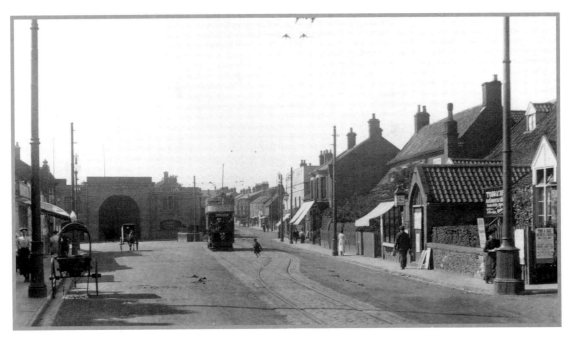

GORLESTON, HIGH STREET 1908 60663

All aboard the number 28 to Gorleston Beach! The electric tramway ran the length of Gorleston, and around to Yarmouth. The station building to the left, built at the same time as the tramway in 1905, was demolished in the mid 1970s.

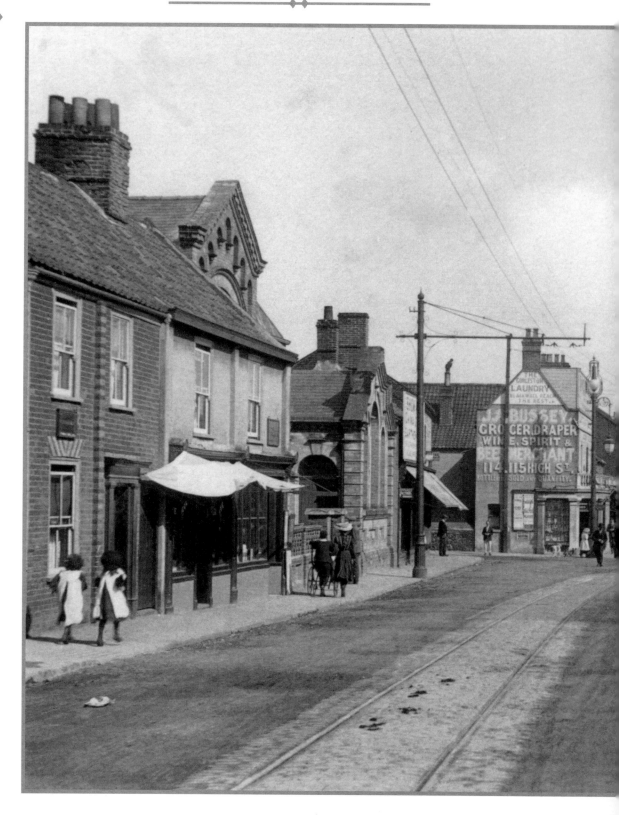

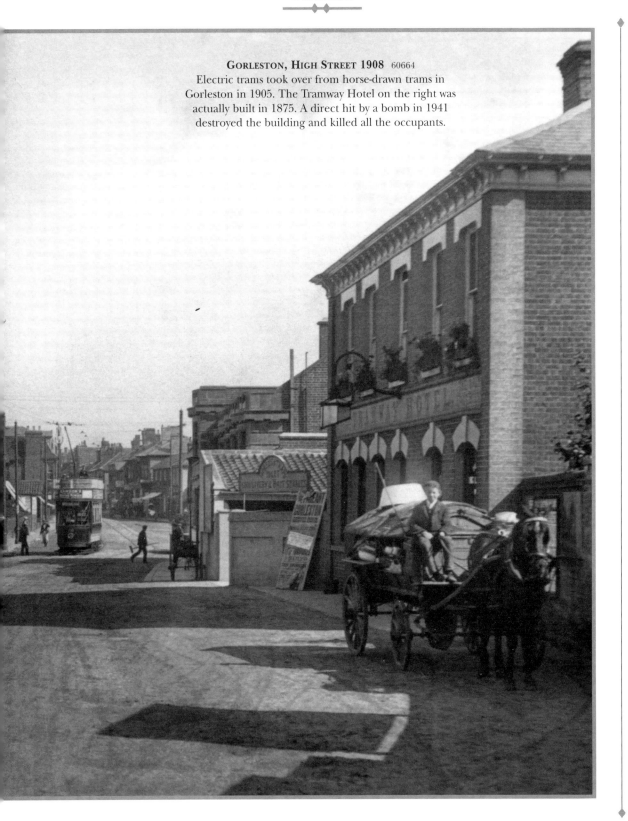

GORLESTON, HIGH STREET 1908 60664
Electric trams took over from horse-drawn trams in
Gorleston in 1905. The Tramway Hotel on the right was
actually built in 1875. A direct hit by a bomb in 1941
destroyed the building and killed all the occupants.

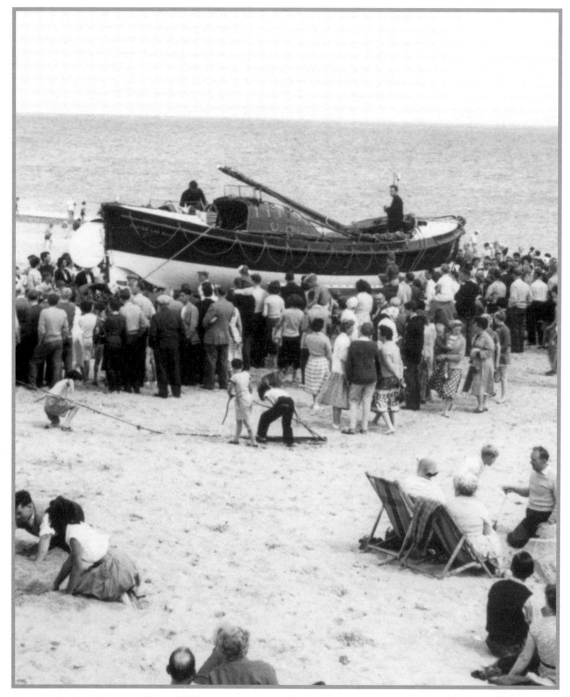

CAISTER-ON-SEA, THE LIFE BOAT c1955 C450112
This is the 'Jose Neville', Caister's first motor lifeboat, which served from 1941 till 1964. Caister, just north of Great Yarmouth, had a strong tradition both for fishing, and for its lifeboat. In 1901, the lifeboat was launched into a storm, and nine out of the twelve crew lost their lives. At the inquiry afterwards, the survivors were asked why they had carried on when conditions made a rescue impossible. Their answer, 'Caister men never turn back', has been the motto of Caister seafarers ever since.

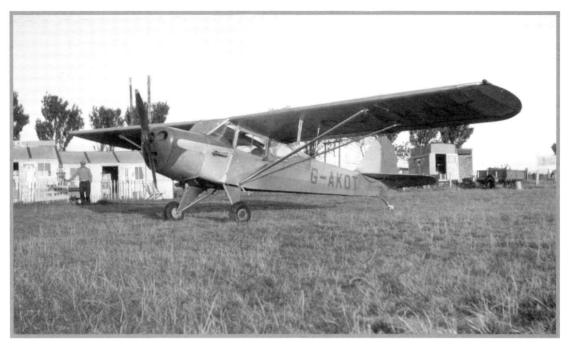

CAISTER-ON-SEA, PLEASURE FLIGHTS c1955 C450300
A short flight in this light aircraft, even just a few hundred feet up, would give the sightseeing holidaymaker a marvellous view of both the coastline, and of the Broads inland.

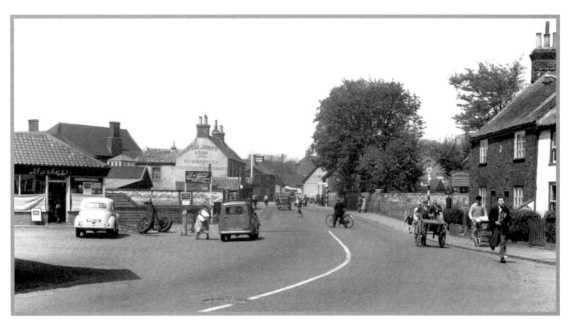

CAISTER-ON-SEA, HIGH STREET c1955 C450078
At the turn of the century, Caister was just a small fishing and farming village. By the mid 1950s, it had already developed a reputation as a holiday destination in its own right, from the early tented holiday camps of the 1930s to the wooden chalets of the more permanent holiday camp which followed, which even had its own railway halt. Along the road on the left is the King's Arms, the oldest pub in the village.

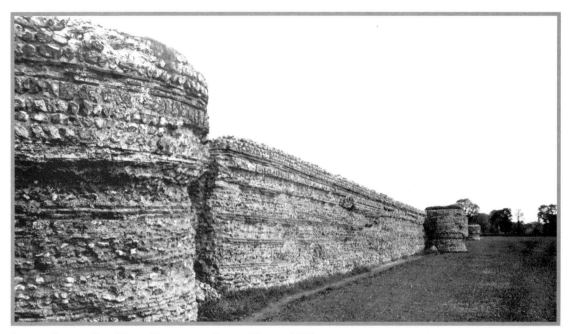

BURGH CASTLE, THE WATCH TOWER AND CASTLE WALLS c1955 B498020

When the Romans built the huge Saxon Shore fort of Gariannonum here at Burgh Castle, it guarded the mouth of a wide estuary, with Caister on the other side. The flint rubble in the walls has eroded more than the better-bonded courses of red tiles, leaving the curious wavy layered effect.

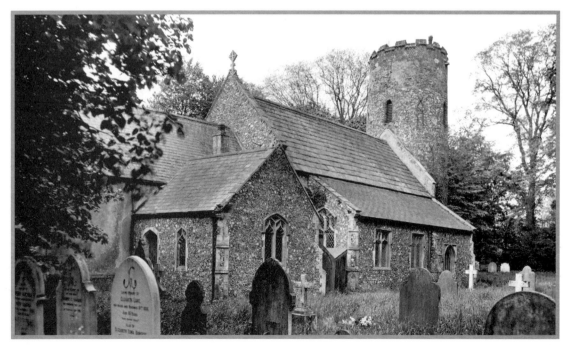

BURGH CASTLE, THE PARISH CHURCH c1955 B498024

The church of St Peter and St Paul stands on the other side of the roman fort to Burgh Castle Village. It has a typical Norman round tower.

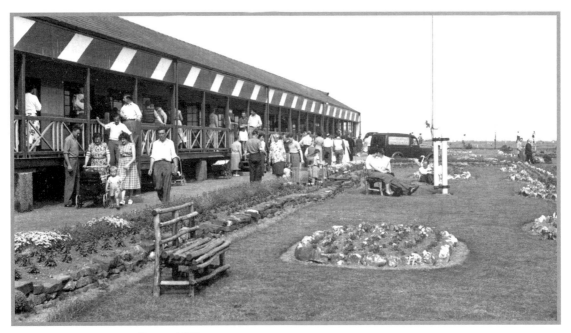

HOPTON, THE HOLIDAY CAMP c1955 H310084
Holiday camps at the early part of the century were literally camps, accommodating visitors in rows of tents. In the post-war years, the wooden chalets and communal activities of the holiday camp would attract thousands of families from the industrial midlands and north.

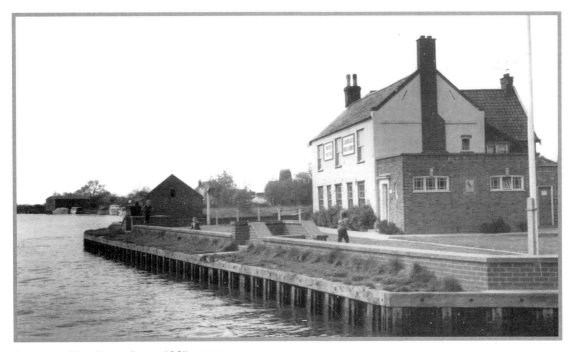

STOKESBY, THE FERRY INN c1965 S469038
If you follow the River Bure from Yarmouth towards Acle, Stokesby is the first village you come to, with plenty of moorings for anyone keen on a little light refreshment!

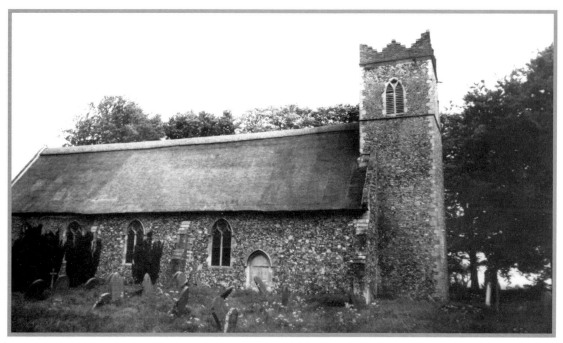

STOKESBY, THE CHURCH c1965 S469049

Here we see the thatched church of St Andrew's, with its churchyard in apparent need of some attention. The church contains benches with open tracery backs, the ends carved with poppy heads.

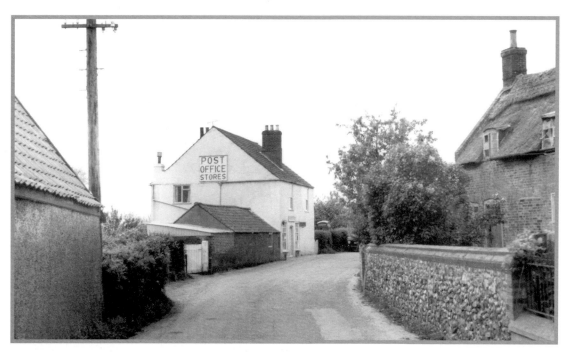

STOKESBY, THE POST OFFICE c1965 S469044

Stokesby is a pretty little village west of Great Yarmouth on the River Bure. The thatched cottage to the right appears to be suffering from significant neglect.

Index

Frith Book Co Titles

Frith Book Company publish over a 100 new titles each year. For latest catalogue please contact Frith Book Co

own Books 96pp, 100 photos. County and Themed Books 128pp, 150 photos (unless specified) All titles hardback laminated case and jacket except those indicated pb (paperback)

Around Barnstaple	1-85937-084-5	£12.99
Around Blackpool	1-85937-049-7	£12.99
Around Bognor Regis	1-85937-055-1	£12.99
Around Bristol	1-85937-050-0	£12.99
Around Cambridge	1-85937-092-6	£12.99
Cheshire	1-85937-045-4	£14.99
Around Chester	1-85937-090-X	£12.99
Around Chesterfield	1-85937-071-3	£12.99

Around Maidstone	1-85937-056-X	£12.99
North Yorkshire	1-85937-048-9	£14.99
Around Nottingham	1-85937-060-8	£12.99
Around Penzance	1-85937-069-1	£12.99
Around Reading	1-85937-087-X	£12.99
Around St Ives	1-85937-068-3	£12.99
Around Salisbury	1-85937-091-8	£12.99
Around Scarborough	1-85937-104-3	£12.99
Scottish Castles	1-85937-077-2	£14.99
Around Sevenoaks and Tonbridge	1-85937-057-8	£12.99
Sheffield and S Yorkshire	1-85937-070-5	£14.99
Shropshire	1-85937-083-7	£14.99
Staffordshire	1-85937-047-0 (96pp)	£12.99
Suffolk	1-85937-074-8	£14.99
Surrey	1-85937-081-0	£14.99
Torbay	1-85937-063-2	£12.99
Wiltshire	1-85937-053-5	£14.99

Around Chichester	1-85937-089-6	£12.99
Cornwall	1-85937-054-3	£14.99
Cotswolds	1-85937-099-3	£14.99
Around Derby	1-85937-046-2	£12.99
Devon	1-85937-052-7	£14.99
Dorset	1-85937-075-6	£14.99
Dorset Coast	1-85937-062-4	£14.99
Around Dublin	1-85937-058-6	£12.99
East Anglia	1-85937-059-4	£14.99
Around Eastbourne	1-85937-061-6	£12.99
English Castles	1-85937-078-0	£14.99
Around Falmouth	1-85937-066-7	£12.99
Hampshire	1-85937-064-0	£14.99
Isle of Man	1-85937-065-9	£14.99

British Life A Century Ago
246 x 189mm 144pp, hardback. Black and white Lavishly illustrated with photos from the turn of the century, and with extensive commentary. It offers a unique insight into the social history and heritage of bygone Britain.

1-85937-103-5 £17.99

Available from your local bookshop or from the publisher

Around Bakewell	1-85937-113-2	£12.99	Feb
Around Bath	1-85937-097-7	£12.99	Feb
Around Belfast	1-85937-094-2	£12.99	Feb
Around Bournemouth	1-85937-067-5	£12.99	Feb
Cambridgeshire	1-85937-086-1	£14.99	Feb
Essex	1-85937-082-9	£14.99	Feb
Greater Manchester	1-85937-108-6	£14.99	Feb
Around Guildford	1-85937-117-5	£12.99	Feb
Around Harrogate	1-85937-112-4	£12.99	Feb
Hertfordshire	1-85937-079-9	£14.99	Feb
Isle of Wight	1-85937-114-0	£14.99	Feb
Around Lincoln	1-85937-111-6	£12.99	Feb
Margate/Ramsgate	1-85937-116-7	£12.99	Feb
Northumberland and Tyne & Wear			
	1-85937-072-1	£14.99	Feb
Around Newark	1-85937-105-1	£12.99	Feb
Around Oxford	1-85937-096-9	£12.99	Feb
Oxfordshire	1-85937-076-4	£14.99	Feb
Around Shrewsbury	1-85937-110-8	£12.99	Feb
South Devon Coast	1-85937-107-8	£14.99	Feb
Around Southport	1-85937-106-x	£12.99	Feb
West Midlands	1-85937-109-4	£14.99	Feb
Cambridgeshire	1-85937-086-1	£14.99	Mar
County Durham	1-85937-123-x	£14.99	Mar
Cumbria	1-85937-101-9	£14.99	Mar
Down the Severn	1-85937-118-3	£14.99	Mar
Down the Thames	1-85937-121-3	£14.99	Mar
Around Exeter	1-85937-126-4	£12.99	Mar
Around Folkestone	1-85937-124-8	£12.99	Mar
Gloucestershire	1-85937-102-7	£14.99	Mar
Around Great Yarmouth			
	1-85937-085-3	£12.99	Mar
Kent Living Memories	1-85937-125-6	£14.99	Mar
Around Leicester	1-85937-073-x	£12.99	Mar
Around Liverpool	1-85937-051-9	£12.99	Mar
Around Plymouth	1-85937-119-1	£12.99	Mar
Around Portsmouth	1-85937-122-1	£12.99	Mar
Around Southampton	1-85937-088-8	£12.99	Mar
Around Stratford upon Avon			
	1-85937-098-5	£12.99	Mar
Welsh Castles	1-85937-120-5	£14.99	Mar
Canals and Waterways	1-85937-129-9		
East Sussex	1-85937-130-2	£14.99	Apr
Exmoor	1-85937-132-9	£14.99	Apr
Farms and Farming	1-85937-134-5	£17.99	Apr
Around Horsham	1-85937-127-2	£12.99	Apr
Ipswich (pb)	1-85937-133-7	£12.99	Apr
Ireland (pb)	1-85937-181-7	£9.99	Apr
London (pb)	1-85937-183-3	£9.99	Apr
New Forest	1-85937-128-0	£14.99	Apr
Scotland	1-85937-182-5	£9.99	Apr
Stone Circles & Ancient Monuments			
	1-85937-143-4	£17.99	Apr
Sussex (pb)	1-85937-184-1	£9.99	Apr
Colchester (pb)	1-85937-188-4	£8.99	May
County Maps of Britain			
	1-85937-156-6 (192pp)	£19.99	May
Around Harrow	1-85937-141-8	£12.99	May
Leicestershire (pb)	1-85937-185-x	£9.99	May
Lincolnshire	1-85937-135-3	£14.99	May
Around Newquay	1-85937-140-x	£12.99	May
Nottinghamshire (pb)	1-85937-187-6	£9.99	May
Redhill to Reigate	1-85937-137-x	£12.99	May
Scilly Isles	1-85937-136-1	£14.99	May
Victorian & Edwardian Yorkshire			
	1-85937-154-x	£14.99	May
Around Winchester	1-85937-139-6	£12.99	May
Yorkshire (pb)	1-85937-186-8	£9.99	May
Berkshire (pb)	1-85937-191-4	£9.99	Jun
Brighton (pb)	1-85937-192-2	£8.99	Jun
Dartmoor	1-85937-145-0	£14.99	Jun
East London	1-85937-080-2	£14.99	Jun
Glasgow (pb)	1-85937-190-6	£8.99	Jun
Kent (pb)	1-85937-189-2	£9.99	Jun
Victorian & Edwardian Kent			
	1-85937-149-3	£14.99	Jun
North Devon Coast	1-85937-146-9	£14.99	Jun
Peak District	1-85937-100-0	£14.99	Jun
Around Truro	1-85937-147-7	£12.99	Jun
Victorian & Edwardian Maritime Album			
	1-85937-144-2	£14.99	Jun
West Sussex	1-85937-148-5	£14.99	Jun

FRITH PRODUCTS & SERVICES

Francis Frith would doubtless be pleased to know that the pioneering publishing venture he started in 1860 still continues today. More than a hundred and thirty years later, The Francis Frith Collection continues in the same innovative tradition and is now one of the foremost publishers of vintage photographs in the world. Some of the current activities include:

Interior Decoration

Today Frith's photographs can be seen framed and as giant wall murals in thousands of pubs, restaurants, hotels, banks, retail stores and other public buildings throughout the country. In every case they enhance the unique local atmosphere of the places they depict and provide reminders of gentler days in an increasingly busy and frenetic world.

Product Promotions

Frith products have been used by many major companies to promote the sales of their own products or to reinforce their own history and heritage. Brands include Hovis bread, Courage beers, Scots Porage Oats, Colman's mustard, Cadbury's foods, Mellow Birds coffee, Dunhill pipe tobacco, Guinness, and Bulmer's Cider.

Genealogy and Family History

As the interest in family history and roots grows world-wide, more and more people are turning to Frith's photographs of Great Britain for images of the towns, villages and streets where their ancestors lived; and, of course, photographs of the churches and chapels where their ancestors were christened, married and buried are an essential part of every genealogy tree and family album.

A series of easy-to-use CD Roms is planned for publication, and an increasing number of Frith photographs will be able to be viewed on specialist genealogy sites. A growing range of Frith books will be available on CD.

The Internet

Already thousands of Frith photographs can be viewed and purchased on the internet. By the end of the year 2000 some 60,000 Frith photographs will be available on the internet. The number of sites is constantly expanding, each focussing on different products and services from the Collection.
Some of the sites are listed below.

www.townpages.co.uk
www.icollector.com
www.barclaysquare.co.uk
www.cornwall-online.co.uk

For background information on the Collection look at the three following sites:

www.francisfrith.com
www.francisfrith.co.uk
www.frithbook.co.uk

Frith Products

All Frith photographs are available Framed or just as Mounted Prints, and can be ordered from the address below. From time to time other products - Address Books, Calendars, Table Mats, Postcards etc - are available.

The Frith Collectors' Guild

In response to the many customers who enjoy collecting Frith photographs we have created the Frith Collectors' Guild. Members are entitled to a range of benefits, including a regular magazine, special discounts and special limited edition products.

For further information: if you would like further information on any of the above aspects of the Frith business please contact us at the address below:
The Francis Frith Collection, Frith's Barn, Teffont, Salisbury, Wiltshire England SP3 5QP.
Tel: +44 (0) 1722 716 376 Fax: +44 (0) 1722 716 881 Email: uksales@francisfrith.com

To receive your FREE Mounted Print

Cut out this Voucher and return it with your remittance for £1.50 to cover postage and handling. Choose any photograph included in this book. Your SEPIA print will be A4 in size, and mounted in a cream mount with burgundy rule lines, overall size 14 x 11 inches.

Order additional Mounted Prints at HALF PRICE (only £7.49 each*)

If there are further pictures you would like to order, possibly as gifts for friends and family, acquire them at half price (no additional postage and handling required).

Have your Mounted Prints framed*

For an additional £14.95 per print you can have your chosen Mounted Print framed in an elegant polished wood and gilt moulding, overall size 16 x 13 inches (no additional postage and handling required).

*** IMPORTANT!**
These special prices are only available if ordered using the original voucher on this page (no copies permitted) and at the same time as your free Mounted Print, for delivery to the same address

Frith Collectors' Guild

From time to time we publish a magazine of news and stories about Frith photographs and further special offers of Frith products. If you would like 12 months FREE membership, please return this form.

Send completed forms to:
The Francis Frith Collection, Frith's Barn, Teffont, Salisbury, Wiltshire SP3 5QP

Voucher for FREE and Reduced Price Frith Prints

Picture no.	Page number	Qty	Mounted @ £7.49	Framed + £14.95	Total Cost
		1	**Free of charge***	£	£
			£	£	£
			£	£	£
			£	£	£
			£	£	£
			£	£	£
				* Post & handling	£1.50

Book Title **Total Order Cost** | £

Please do not photocopy this voucher. Only the original is valid, so please cut it out and return it to us.

I enclose a cheque / postal order for £
made payable to 'The Francis Frith Collection'
OR please debit my Mastercard / Visa / Switch / Amex card

Number .

Expires Signature .

Name Mr/Mrs/Ms .

Address .

. .

. .

. Postcode

Daytime Tel No . Valid to 31/12/01

The Francis Frith Collectors' Guild

Please enrol me as a member for 12 months free of charge.

Name Mr/Mrs/Ms .

Address .

. .

. .

. Postcode

Free Print - see overleaf